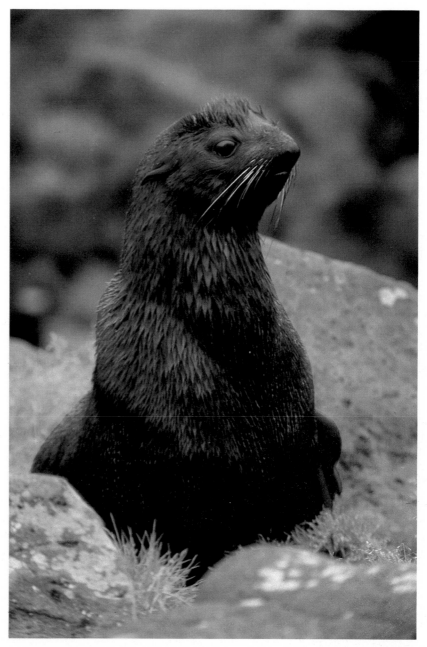

Northern fur seal,
Pribilof Islands, Bering Sea.

Fall in the Chugach Mountains.

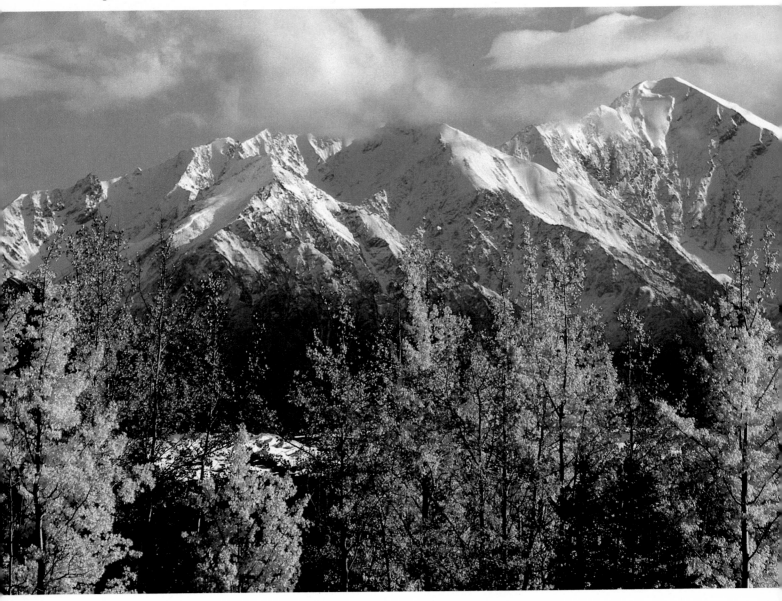

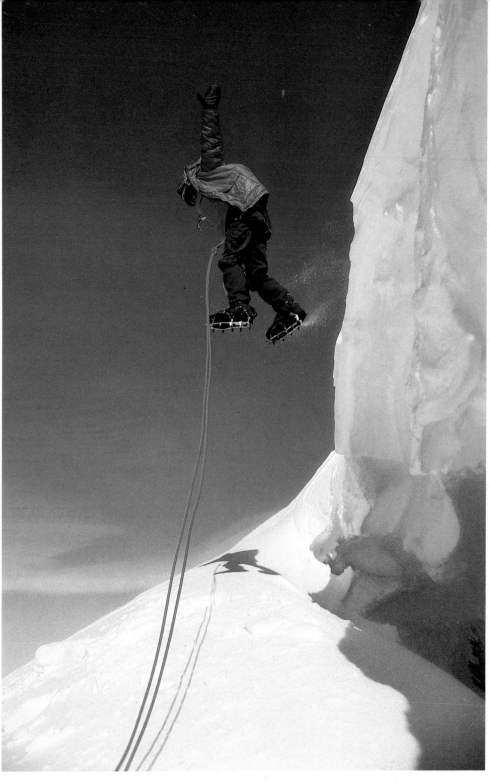

Jumping a crevasse on Mount McKinley.

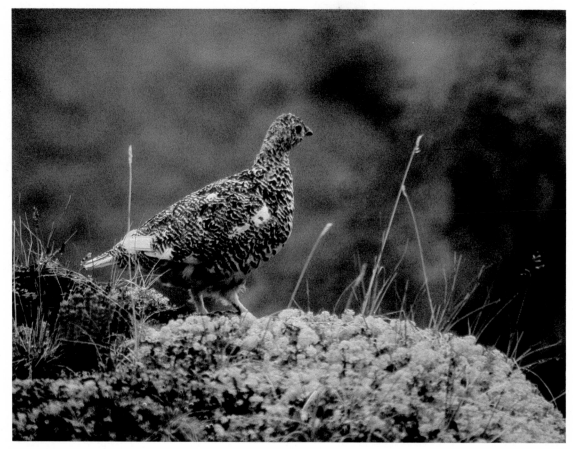

White-tailed ptarmigan.

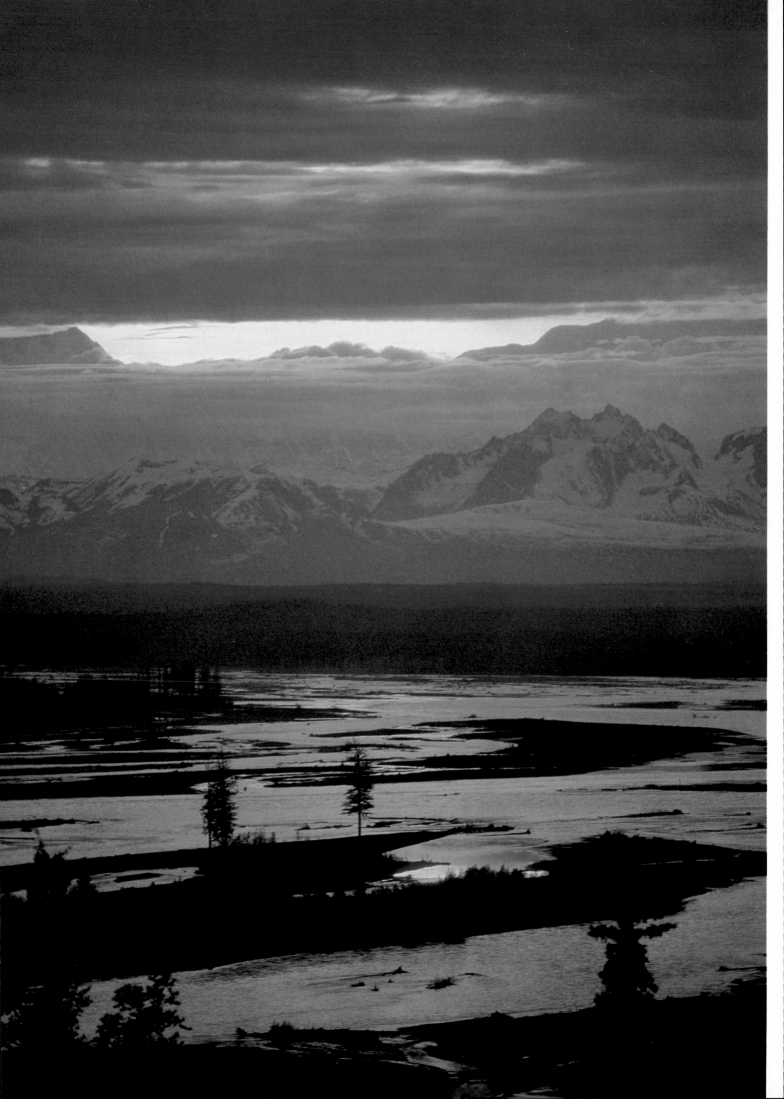

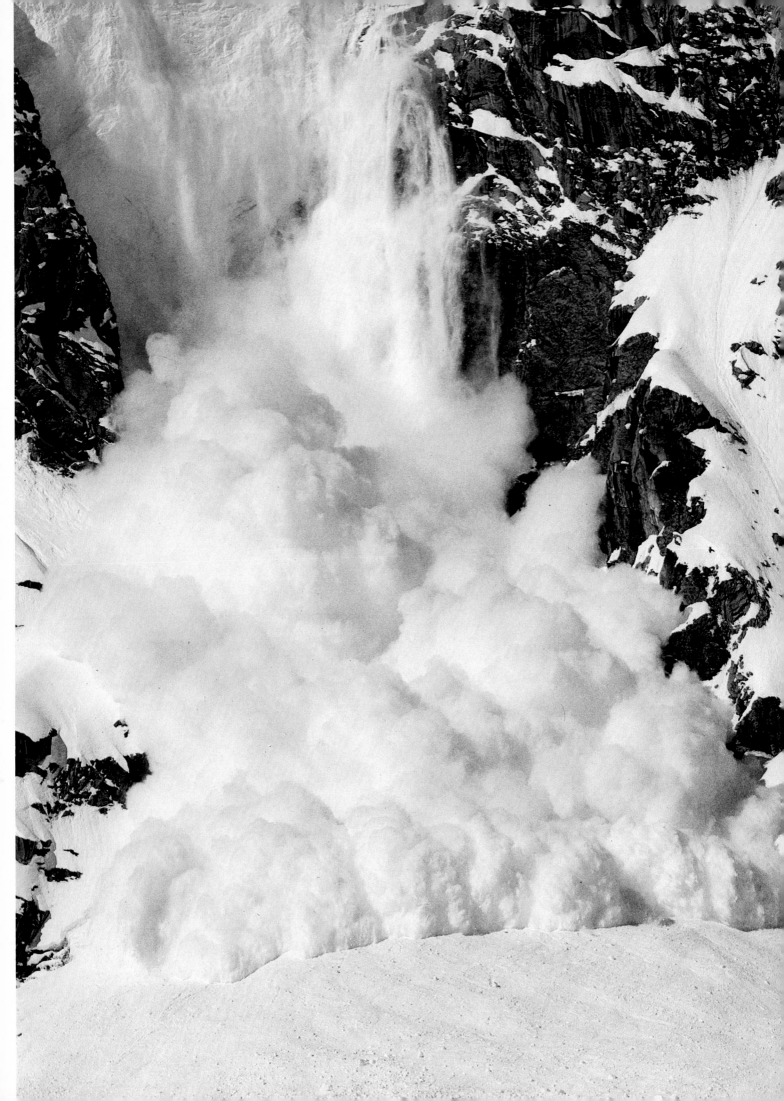

ALASKA
IMAGES OF THE COUNTRY

PHOTOGRAPHS AND TEXT SELECTION BY Galen Rowell

TEXT BY John McPhee FROM *COMING INTO THE COUNTRY*

SIERRA CLUB BOOKS / SAN FRANCISCO

FRONTISPIECE:
*Massive avalanche in the Don Sheldon
Amphitheater under Mount McKinley.*

The Sierra Club, founded in 1892 by John Muir, has devoted itself to the study
and protection of the earth's scenic and ecological resources – mountains,
wetlands, woodlands, wild shores and rivers, deserts and plains. The pub-
lishing program of the Sierra Club offers books to the public as a nonprofit
educational service in the hope that they may enlarge the public's under-
standing of the Club's basic concerns. The point of view expressed in each
book, however, does not necessarily represent that of the Club. The Sierra Club
has some fifty chapters coast to coast, in Canada, Hawaii, and Alaska.
For information about how you may participate in its programs to preserve
wilderness and the quality of life, please address inquiries to
Sierra Club, 530 Bush Street, San Francisco, California 94108.

The text from *Coming Into the Country* copyright © 1976, 1977, 1981
by John McPhee, reprinted by arrangement with Farrar, Straus & Giroux, Inc.
The photographs copyright © 1981 by Galen Rowell.

Library of Congress Cataloging in Publication Data

Rowell, Galen A.
 Alaska: images of the country.

 1. Alaska – Description and travel – 1959–
2. Natural history – Alaska. I. McPhee, John A.
II. McPhee, John A. Coming into the country.
III. Title.
F910.R68 979.8'05 81-5265
ISBN: 0-87156-290-1 AACR2
ISBN: 0-87156-293-6 (deluxe ed.)

10 9 8 7 6 5 4 3 2 1

CONTENTS

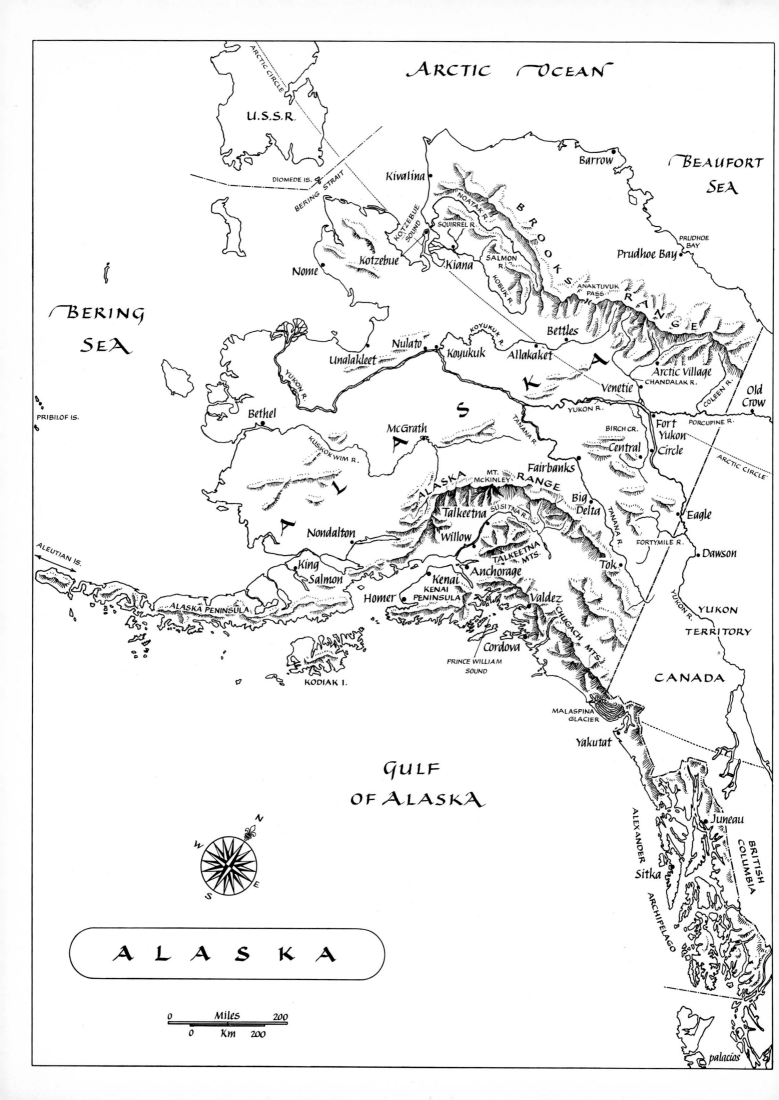

PREFACE

IN AN ERA when rapid change is taken for granted, the pace of transformation in Alaska during the last decade has far outstripped that of any other state. Ten years ago Alaska was almost entirely open to public use by prospectors, wandering bands of Indians and Eskimos, and far less romantic corporate interests. The passage in 1971 of the Alaska Native Claims Settlement Act marked the beginning of radical changes in land use; the proverbial "last frontier" has since been closing at a rate unprecedented in American history.

The Act, the most complex single law ever made, granted to Alaska's indigenous peoples about 40 million acres – a tenth of the state – along with a billion dollars. It also set aside about 100 million acres for eventual designation as some form of federal protectorate; the Secretary of the Interior was to choose national parks, national forests, wildlife refuges, and wild and scenic rivers. The fate of these D2 lands (so called after section 17d(2) of the Act) was conditional on Congressional approval following a study period, but any hope that the process would run smoothly was soon dashed by the struggle that developed among major conflicting interests. Environmentalists were eager to preserve as much as possible of Alaska's wild heritage for future generations; developers feared that such action would cripple the state's economic boom; and the state of Alaska was distinctly impatient to resolve the matter of 103 million acres promised to it under the Statehood Act of 1959 but still unchosen and undelivered.

The D2 lands remained in limbo while the controversy over the Trans-Alaska pipeline flared, and by late 1977, when the oil began to flow, the battle was still being fought in Congress. On December 2, 1980, the long-awaited Alaska National Interest Lands Conservation Act, which instantly tripled the size of wilderness areas in the nation and doubled that of national parks and wildlife refuges, was signed into law by President Carter.

The events that led to the creation of this book coincided with the last years of the great debate over Alaska's future. John McPhee's *Coming Into the Country* was published in 1977 and became a national bestseller. I read the book in 1978, shortly after returning from my sixth trip to Alaska. In 1979, when I first approached McPhee with the idea for a volume that would combine my photographs with excerpts from his book, it seemed to me that the project could be a beautiful and fitting celebration of the greatest land conservation legislation in history. I was aware that each of us had broader original intentions for our separate work, but I was content to think of the book as a depiction of Alaska during a unique era of decision.

The project underway, I asked McPhee if he would contribute a preface, imagining a few sharply etched paragraphs that would summarize the intent of our joint effort. McPhee politely declined, explaining in a letter, "I wouldn't know what to say. The project was not conceived by me, you and I can't claim to be old associates, we can't even claim to know each other. The idea was yours, the impetus yours, and I think the far

better preface would be written by you." My initial disappointment at his refusal was soon replaced by appreciation of the opportunity it offered to explore the connections between my personal experience, the Sierra Club, and McPhee's writing.

Before tying any connecting knots, I feel a need to disclaim any significance for them beyond what they are. Too much of modern writing is based upon conspiracies implied by a few carefully chosen examples. In the present case, the reader may need some extra assurance that Sierra Club policies with regard to Alaska have not shifted the objectivity of McPhee's text by selective editing. I chose the excerpts; and with regard to the photographs, the main challenge was to avoid unintentional commentary in their use. The subjects overlapped the text at many points, and McPhee cautioned me not to "overprint" his verbal pictures with my own. From ten thousand photographs made during nine journeys to Alaska, the editors and I have chosen 110 that complement rather than "illustrate" the text. The strongest editorial hand on my work was mine, and the independent work of two men with independent visions has been preserved in the best tradition of finely reproduced Sierra Club books on wildlands.

I first came on John McPhee's writing in his series of *New Yorker* articles that was later published as the book *Encounters with the Archdruid* in 1971. I was entranced because I knew the Archdruid; David Brower lived around the corner from my family's home in Berkeley, and I had interviewed him for a term paper when I was thirteen. The accuracy and perceptiveness of McPhee's portrait of Brower left me with a new awareness of the potential of nonfiction literature.

My childhood interview with Brower had produced a rather tedious description of a legal battle over the building of a dam in Dinosaur National Monument on the Utah-Colorado border. It was not without significance in the genesis of this book, however, for what happened there turned

out to be a conservation milestone on the direct line of ascendancy to the battle royal over Alaska. Brower was the Sierra Club's executive director when he decided that the issue warranted the club's first environmental stand outside California, and it was a key stage in the transformation of a local outing club into a worldwide force for environmental activism.

Brower's role as a publisher is another thread in the web. In *Encounters with the Archdruid,* McPhee wrote:

In 1960, in Yosemite Valley, Brower helped together an exhibit of landscape photographs and accompanying swatches of prose.* Then he developed the idea of circulating the exhibit in book form. The result was the Sierra Club's Exhibit Format Series— big, four-pound, creamily beautiful, living-room-furniture books that argue the cause of conservation in terms, photographically, of exquisite details from the natural world and, textually, of essences of writers like Thoreau and Muir. Brower was editor and publisher. He selected the photographs. He wrote the prefaces.

My own books bear the mark of Brower's concept. The three most recent contain text I have written blended with photography, and before reading *Coming Into the Country* I had been considering a solo effort on Alaska. I knew from experience, however, that I do my best writing in a noncompetitive vacuum where I can imagine, regardless of how true it is, that what I am doing is unique and definitive. I could not imagine outdoing McPhee. So in 1979 I wrote him a long letter about our serendipitous encounters with the Archdruid and proposed the idea for this book. The response was slow in coming but gratifying, and the details were subsequently resolved by our respective publishers, Sierra Club Books and Farrar, Straus & Giroux.

I made another trip to Alaska to shoot some of the places described in *Country*, and met some of the major characters in McPhee's narrative. These meetings gave me insights into McPhee's

*The photographs were those of Ansel Adams.

method, and why, unlike so many "reporters," he has earned the lasting respect of his interviewees. In the case of these Alaskans, such respect is not granted lightly.

Few if any writers have been as successful as John McPhee in giving solid journalism the taste of fine literature. The elegance and complexity of his style never obscure the substance of what he has to say. A major source of McPhee's power is his ability, as described by the *Wall Street Journal*, to present "great differences of opinion with integrity on all sides . . . concrete situations where factors are complex and decisions hard. Readers must choose sides."

Alaska and its recent past are a subject well matched to McPhee's skills, and it would be unfortunate if his readers chose sides before hearing him out. To do so is to risk losing the broadest perspective on complex issues that McPhee wisely has not moralized about. I have had experiences in Alaska that support both sides. My background in conservation and wildlife study makes me a strong advocate of parks and wilderness in Alaska, yet had I been raised there I might well have become part of the backlash against federal protection of wildlands. Quite simply, the majority of Alaskans today resent their federal government, and such widespread sentiment is difficult and dangerous to dismiss. McPhee provides numerous examples of conflicts between individuals and government, yet few, if any, that support the belief, common in the Lower Forty-eight, that the controversy was between "those who would exploit all of Alaska and those who would protect a reasonable portion." This truism omits the government's role and leaves the urban conservationist wondering why all those Alaskans who must love the great outdoors were so vehemently against parks and wilderness. Most Alaskans were not strongly opposed to land conservation; they simply dreaded the often insensitive and inequitable conservatorship practiced by federal agencies.

It is not my place to moralize where McPhee does not; nor do I wish to "overprint" his impressions with either photography or personal anecdotes. Suffice it to say that my experiences in Alaska directly affirm much of what he relates. The difference, of course, is that they were *mine*; reading about an experience never creates the same response as living it. In some cases—dramatic episodes such as being charged by a bear or falling into a hidden crevasse—the differences are a matter of intensity and small detail. In others, whole realms of experience defy the written word. Even McPhee's prose cannot satisfy an empty stomach or an aching heart, nor can it make us understand fully what it means to be an Indian or Eskimo. During my travels in Alaska for the photographs in this book, several incidents with federal agencies destroyed for me a measure of my faith, innocence, and sense of freedom within the American system. I doubt that any written words could have had the same effect.

It is generally acknowledged that the 1980 Lands Act was the absolute peak in the curve of land and wildlife legislation. In my lifetime, I do not expect to see an area of similar size set aside anywhere on earth. In the preparation of this book I have reread McPhee's text at least a dozen times, and with each reading I see the broad outline of an environmental message more clearly. The challenge of the future, both for conservationists and political leaders, is the immense task of changing the current adversary relationship between government and the governed. Until this is achieved, future environmental legislation may be severely compromised. Today many Alaskans are so bitter that state legislators have serious discussions about seceding from the union, and the new U. S. senator campaigned on his opposition to the federal government. Such bitterness, however, is in no way exclusive to the Alaskan character. I'm reminded of the Canada geese that migrate to Alaska each year. Observers used to think that there were distinct wild geese and tame geese; one would flee at the sight of a human, while the

other would eat out of a hand. Behavioral studies made the error obvious: the same bird would act wild in one pond along its migration path and tame in another, in response to the treatment it had received from people on previous visits. When the dust settles from the Lands Act, and when government manners improve, the wild and rugged North will be improved habitat for both humans and wild things.

Meanwhile, I hope that this book fulfills at least its original intent. If it introduces John McPhee to a few new readers; if the images reveal aspects of Alaska previously unfamiliar to viewers – so much the better. Certainly few authors have been as fortunate in their collaborators as I am in this book; for me, the opportunity to explore the ties between two people who "can't even claim to know each other" is cause enough for celebration.

Berkeley, California Galen Rowell

PART ONE

In Urban Alaska

Birch forest above the Matanuska River.

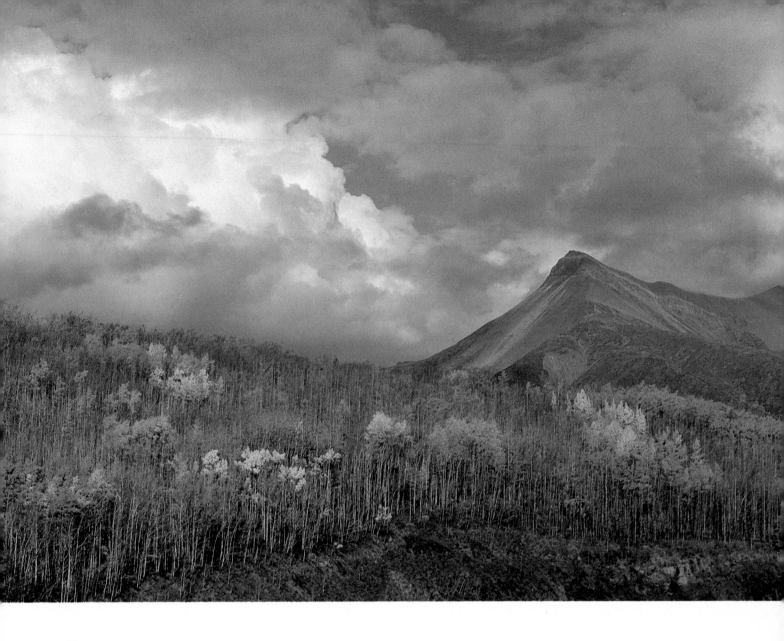

ONE MORNING in the Alaskan autumn, a small sharp-nosed helicopter, on its way to a rendezvous, flew south from Fairbanks with three passengers. They crossed the fast, silted water of the Tanana River and whirred along over low black-spruce land with streams too numerous for names. The ground beneath them began to rise, and they with it, until they were crossing broad benchlands and high hills increasingly jagged in configuration as they stepped up to the Alaska Range.

At about the same time, another and somewhat larger group took off from Anchorage in a de Havilland Twin Otter, and this sturdy vehicle, firm as iron in the air, flew north up the valley of the Big Su—Susitna River, a big river in a land of big rivers—and on up over alpine tundra that now, in the late season, was as red as wine. After moving over higher and higher hills, the plane moved in among mountains: great, upreaching things, gray on the rockface and then—above the five-thousand-foot contour and far on up, too high to see without pressing to the window—covered with fresh snow.

"Is the mountain out?" someone on the right side of the plane wanted to know. In so many mountains, there was one mountain. "Is the mountain out?"

"It surer than hell is."

"It never looks the same."

3

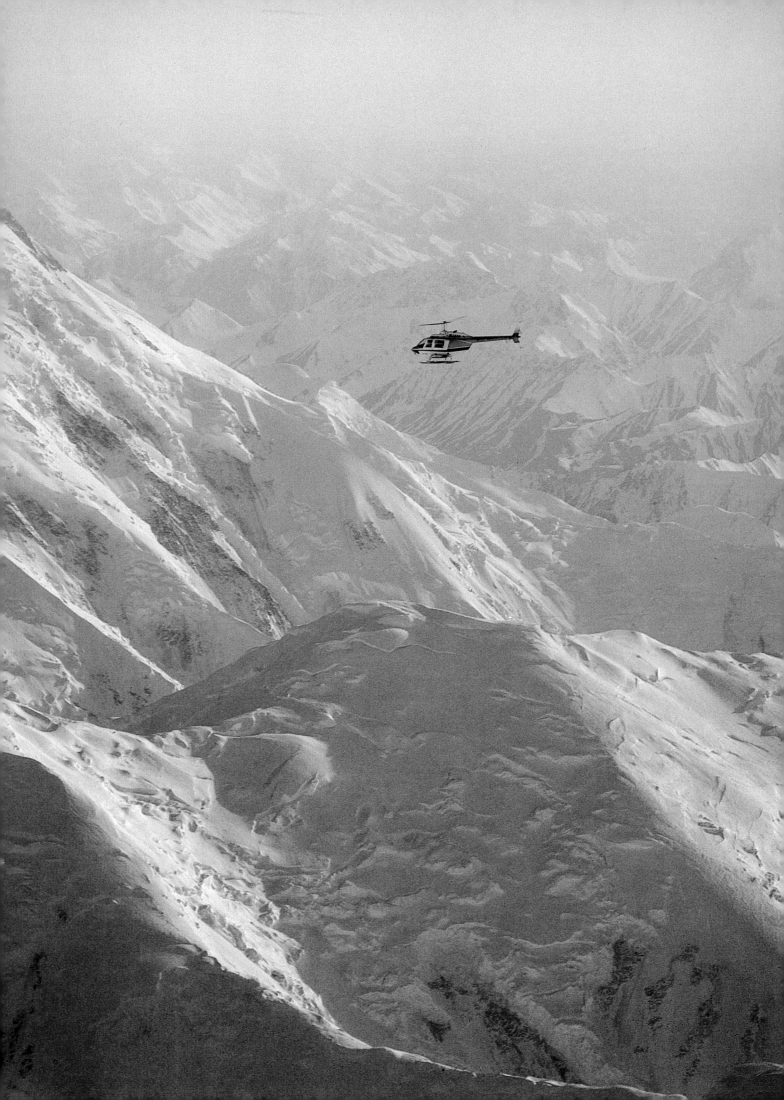

The mountain was a megahedron – its high white facets doming in the air. Long snow banners, extending eastward, were pluming from the ridges above twenty thousand feet.

"What would you call that mountain, Willie?"

"Denali. I'll go along with the Indians that far."

Everyone aboard was white but Willie (William Iġiaġruq Hensley), of Arctic Alaska, and he said again, "Denali. What the hell did McKinley ever do?"

The Twin Otter by now was so deep in the Alaska Range that nothing could be seen but walls of mountain in a pass. Then, finally, the pass widened the way to the north. Banking over terraces and high riverine bluffs – Nenana River – the plane landed on gravel near a small group of buildings, a mining town. The helicopter from Fairbanks was already there. Handshakes all around. Brisk, nippy morning, right? Won't be long now. And then, in threes and fours, the group made successive flights in the small helicopter – down the right bank of the Nenana over the broad high benchland, back and forth in loosely patterned flight. Four grizzly bears – large and small, perhaps a ton or so of bear – were grazing a meadow below, eating blueberry bushes rich with fruit. The helicopter ignored the bears. It crossed the river and flew back to the north in vectors, as if looking for something. A small lake. Then a larger lake. This was indeed a hunt, and what the people in the air were hunting for was a new capital of Alaska.

WHEN STATES move their capitals, as most of them have done at one time or another, the usual aim is to have a seat of government somewhere near the centers of geography and population – criteria that distinctly fail to describe Juneau. Juneau, capital of Alaska since 1900, is in the eccentric region that Alaskans call Southeastern – a long, archipelagic claw that dangles toward Seattle and is knuckled to the main body of Alaska by a glacier the size of Rhode Island.

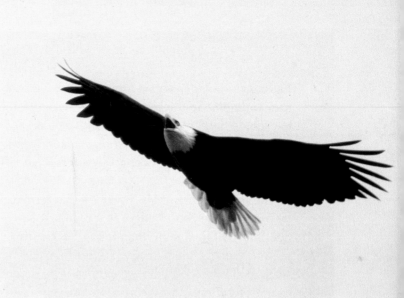

Bald eagle, Susitna Valley.

Southeastern Alaska reaches so far east that all the land north of it is Canadian. British Columbia. Yukon Territory. Juneau is two time zones from Anchorage, from Fairbanks, from the center of the state. It is twenty-five hundred miles from the other end of Alaska. Many Alaskans do not regard Southeastern as part of Alaska but, rather, as an appendage of inconvenience, because Juneau is there. Juneau is an outport – cannot be reached, or even approached, by road. Juneau was the site of a gold strike that attracted people enough to make a town, and the town's importance increased when strikes of bonanza quantity were made in mountains to the north, along the Klondike River and other tributaries of the upper Yukon. Juneau, already a mining town, was also a way station on trips to the Klondike, and it became – for the duration of the gold boom – a center of Alaskan commerce.

Anchorage is the commercial center now, and roughly half of political Alaska. As a result of a petition signed by sixteen thousand, an initiative appeared on the 1974 primary ballot through which the voters could indicate a wish to move their capital. Similar initiatives in 1960 and 1962 had been defeated, perhaps in part because Alaskans elsewhere in the state did not want to see even more power concentrated in Anchorage. Anchorage, for its part, wished to yield nothing to

5

Helicopter over the Alaska Range.

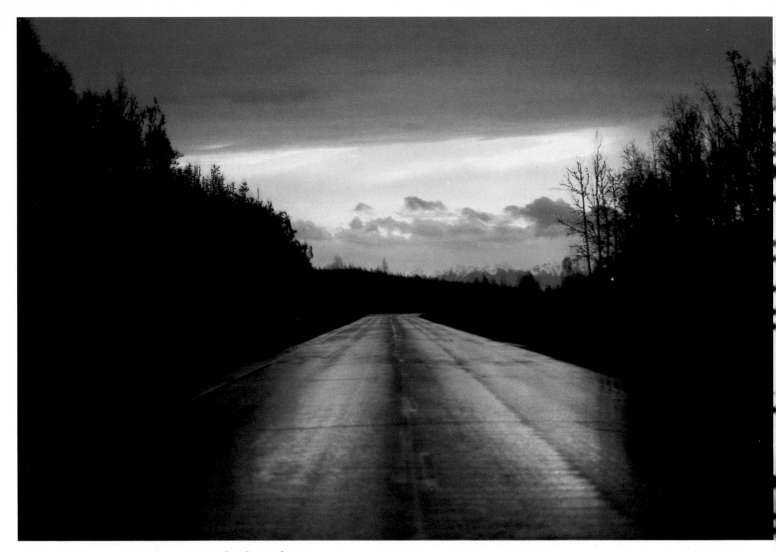

A rainy dawn on the Anchorage – Fairbanks Highway.

because everybody in Alaska hates Anchorage it is politically expedient to put the capital in a new place, an undeveloped place."

"The land out there is of no great value. It's just wilderness, standing there."

THE COMMITTEE'S FLIGHT through the mountains that morning appeared to be, as much as anything else, a gesture of courtesy to Fairbanks, *de facto* capital of the terrain that is called the Interior. Fairbanks is the pivot from which travellers fan out to the north – the usual departure point for Arctic Alaska, and the departure point, as well, for mail planes and bush craft that serve the Interior villages. A look at a map would suggest a site near Fairbanks as an obvious capital for the state as a whole, because of Fairbanks' position near the center of the Alaskan mainland. There are drawbacks, however, in climate. The Interior is so named because it lies between the Brooks Range, which traverses the far north, and the Alaska Range, which is the climax of the mountain chain that comes up the Pacific coast and then bends across south-central Alaska to indicate the Aleutians. The Interior is the hottest region of Alaska It is also the coldest. Temperatures there can go into the nineties in summer and into the minus-seventies in winter, and at times of deep cold large areas of the Interior will be palled with ice fog. Fairbanks has more motor vehicles per capita than does Los Angeles, and as the cars toot and tap

8

bumpers on the long crawls through the ice fog the warm gases of their exhaust plumes seem to stick in the air close around them—an especially pernicious, carcinogenic subarctic variety of smog. This experience would suggest—too late to help Fairbanks—that it might be imprudent to plan deliberately to attract numerous vehicles to a single site in the Interior.

The capital committee got into the Twin Otter and flew back through the mountains toward the south. "A great place for grizzlies," said Willie Hensley, looking over his shoulder.

In its many months of sorting possibilities, the committee had discovered that there were few places in Alaska that could meet the criteria of the search. By law, resulting from the terms of the initiative, they had to find a hundred square miles of land somewhere near a road and a railroad and in terrain appropriate for a new airport that would consistently experience negotiable weather. The land had to belong to the state, or, in any case, to be available to the state for nothing. In addition, the committee and its consultants established standards of their own. Since weather and cold worsen with altitude, they would look for a site below two thousand feet. It should have, among other things, good soil, ample water, topography both practical and aesthetically appealing, relatively modest annual snowfall. It should not inconvenience resident wildlife—should not invade bear-denning grounds, salmon-spawning areas—and it should not be in zones of earthquakes or volcanism.

A simple task. In Indiana. Corydon was the capital of Indiana until a new-capital-site-selection committee drew a state-size X on the map and noted where the legs crossed. The spot was in deep forest. Indians owned the land. A treaty took care of them. Indianapolis, Indiana.

This was Alaska, though, where people are even more marginal than plants, and the choice was truly complex. About a third of Alaska is above two thousand feet. Something like two-thirds is demarcated for the natives and the fed-

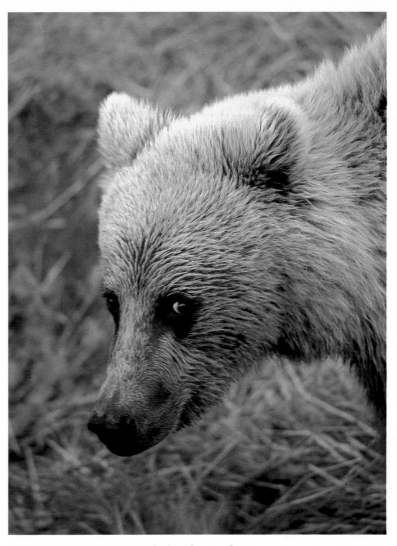

Close encounter with an Alaskan brown bear.

Caribou bull emerging from a bed of willows, Mount McKinley National Park.

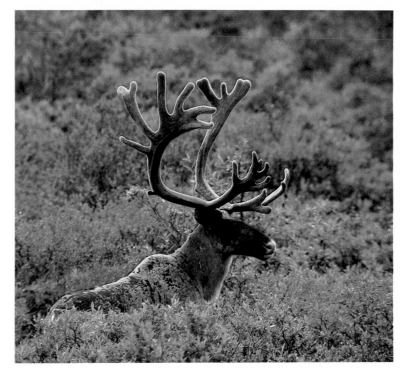

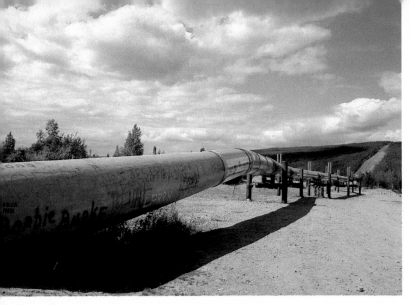

An ancient sea of oil drains slowly southward through the Trans-Alaska Pipeline.

eral government. It would be unwise to build in an area of permafrost. Two-thirds of Alaska is underlaid by permafrost. Alaska has two railroads. One is twenty-six miles long. The other runs four hundred and seventy miles, from Seward—a port on the Gulf of Alaska—through Anchorage and on to Fairbanks. The Alaska Highway comes into the Interior from Yukon Territory. The rest of the state's highway system principally consists of two roads. One goes from Fairbanks to Anchorage, and the other, by a newer and more westerly route, goes from Anchorage to Fairbanks. Roughly speaking, the land that has been built upon, pipelined, or otherwise trammelled in Alaska—all the land that is now taken up by towns, villages, cities, airports, trapper cabins, motels, roads—consists agglomerately of less than a hundred thousand acres. That leaves, untouched, nearly three hundred and seventy-five million acres. By almost any standards drawn from the North Temperate Zone, human settlement is still the next thing to nonexistent in Alaska. Juneau, a relatively small town of eighteen thousand, is Alaska's third-largest "city." The celebrated Trans-Alaska Pipeline is, in scale, comparable to a thread laid across Staten Island. With it, the "destruction of Alaska" may have begun, as some people will say, but utter wilderness—uncompromising, unhuman wilderness—is almost wholly what Alaska is now. So if a group of people had to choose a townsite near a road and a rail-

road, off permafrost and on fairly low but well-drained ground, and not inordinately far from the main pockets of existing population, nearly all of Alaska would recede from the conversation and by the facts the people would be ushered into the Susitna Valley.

The Twin Otter, coming out of the mountains, moved south above the Susitna, whose water, flowing swiftly, bore so much glacially pulverized rock that it was gray and glisteningly opaque, and appeared to be ready to set. The upper Susitna has cut a canyon—Devils Canyon—where rapids pile up almost to the scale of the Colorado; and then the currents spread out and braid their way among uncountable islands. The Susitna Valley—to a point more than a hundred miles above Anchorage—includes the most northerly penetration in Alaska of land that is generally free from permafrost. The Alaska Railroad goes up the valley, as does the Anchorage-Fairbanks Highway, which was opened in 1974—significant marks, to be sure, of advancing humanity, but from the low-flying plane they looked in the forest like a slim ribbon and a set of sutures. An occasional

Mural in downtown Fairbanks.

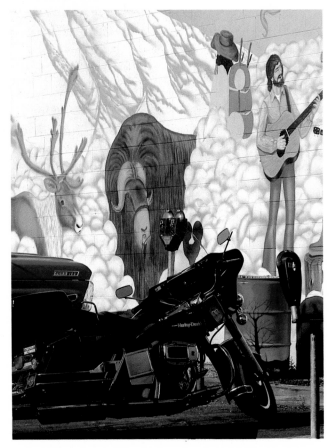

10

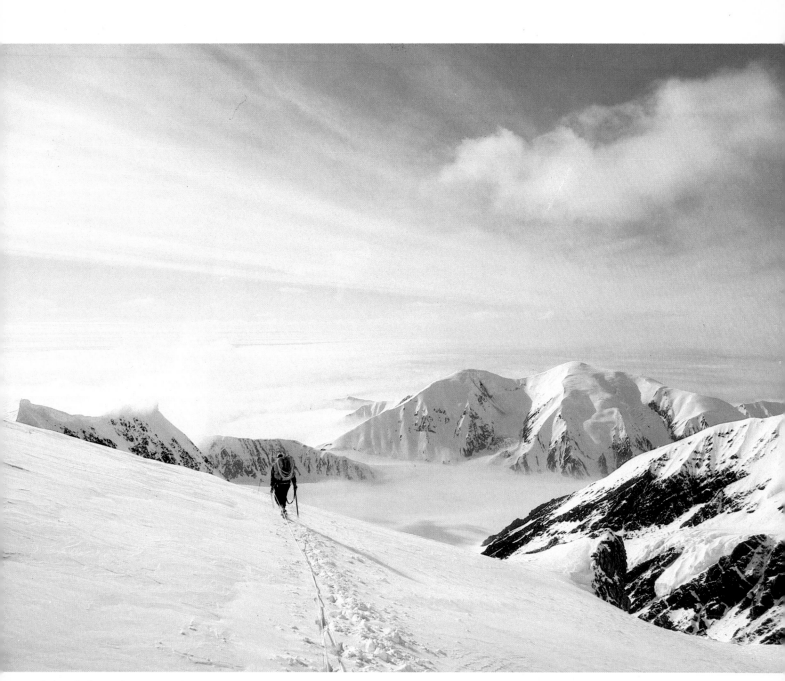

Ice and cloud above the Peters Glacier on Mount McKinley.

roadhouse, cabin, or clearing appeared along the highway, and there were other cabins beside streams splaying out from the railway. A train – Lionel in appearance among the black lowland spruce – was stopped near a stream in the undepoted wild. Someone was collecting supplies. Or getting off to go home. The railway serves many dozens of people who have abandoned the civilization the railway represents. The train, typically, drops them at a stream and they go in canoes or skiffs to cabins some miles away. They chose the cabin sites and staked them out as "Open to Entry" land, which was available for low sums until 1973, when the program was at least temporarily stopped, pending the resolution of all the major

Frances Randall's summer job, maintaining a landing site for bush pilots on the Kahiltna Glacier, leaves her time to practice for performances with Alaska's state orchestra.

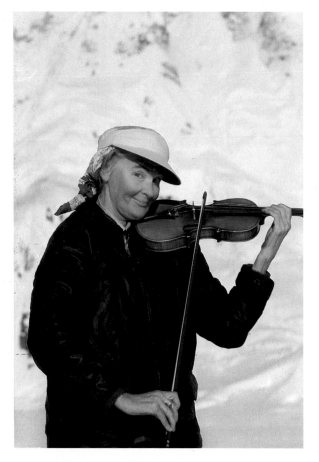

and interlocking events in the subdivision of Alaskan land: final selection by the state of the one hundred and three million acres allotted to it in the Statehood Act, in 1958; final designation of intended use – parks, refuges, national wild rivers – for vast segments of federal lands; and selection by the natives of the tracts to be deeded to them. When the Open to Entry program was set up, recreation was what its creators had in mind. But a number of people who staked lots went to live on them year round – to combat the winter, to live in wilderness, to kill and eat game, to trap fur, to simplify their lives and be relatively self-sufficient, albeit in some dependence on the Alaska Railroad. Making money was emphatically not their objective. They sought little more than permanent relief from the larger society. To place a city down among them would be to flick them from the earth. Willie Hensley and the committee, overhead, looked down over the spruce-and-hardwood forest. A couple of cabins were barely visible among the trees. Aspen leaves, yellow, were quaking in the fall air. "Too mundane," Willie Hensley said as the Twin Otter moved on toward Talkeetna.

A minor but handsome run of mountains – the Talkeetna Mountains – now framed the valley with a six-thousand-foot ridgeline to the east. To the west, the land was at first low and then rose toward mountains beyond which were only a few specks of settlement in the five hundred miles to the Bering Sea. To the north, roughly forty miles distant now, was the topographical mural that closed off the Interior. Mount McKinley, veiled in snow haze, was fast removing itself to obscurity. The big mountain, sometimes described as the Weathermaker, creates its own integument, because it is so high and cold that when it interrupts flows of warm and often moist summer air it causes violent reactions: roiling clouds that form in a moment, sudden storms, gale-driven blizzards. High up the mountain, the windchill – even during the elsewhere-warm Alaskan summer – can go down to (and beyond) a hundred

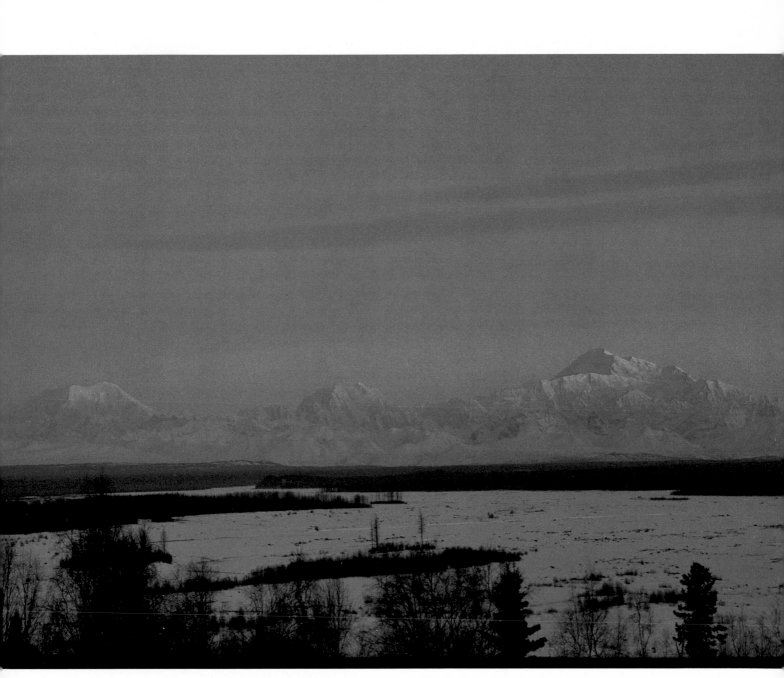

Winter dawn, Mount McKinley above the frozen Susitna River.

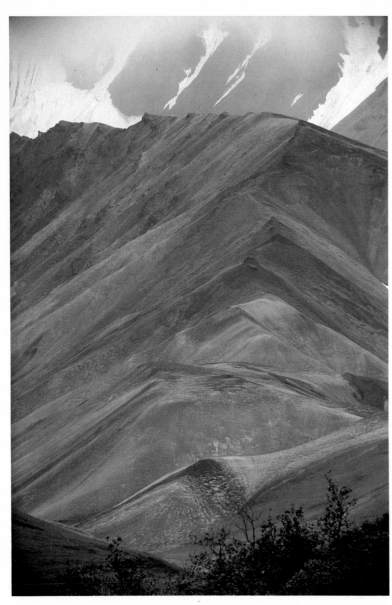

The variegated foothills of the Alaska Range.

difference – between your altitude near sea level and the height of that flying white mountain – is much too great to be merely overwhelming. The mountain is a sky of rock, seemingly all above you, looming. Until it takes itself away, you watch it as you might watch a hearth fire or a show in color of aurorean light. The provocative immensity of Mount McKinley seems to symbolize Alaska to many Alaskans. No wonder they would have a capital with the mountain much in view. Some of those Alaskans, as it happens, are Athapaskans, and their regard for the big mountain is understandably deeper (in time, in metaphor, in spiritual mystery) even than the regard of white Alaskans. The Athapaskans are not much impressed that a young Princeton graduate on a prospecting adventure in the Susitna Valley in 1896 happened to learn, on his way out of the wilderness, that William McKinley had become the Republican nominee for President of the United States. In this haphazard way, the mountain got the name it would carry for at least the better part of a century, notwithstanding that it already had a name, for uncounted centuries had had a name, which in translation has been written, variously, as The Great One, The Mighty One, The High One. The Indians in their reverence had called it Denali. Toponymically, that is the mountain's proper name; and if a city were deliberately to seek the mountain and appear before it, the city might be Denali, too.

TALKEETNA, the only community of any size in the upper part of the valley, voted sixty-nine to forty-two in favor of moving the capital. Talkeetna is a prime collecting point for climbers on their way to McKinley. I once saw a Japanese climber in Richard and Dorothy Jones's store there, buying a cabbage. It was a purple cabbage and somewhat larger than his own head, which was purple as well, in places, from contusions and sunburn, and probably windburn, suffered in his bout with the mountain. On his cheek was a welted wound, like a split in a tomato. Leaving the store, he walked

below zero. From within its vapors, the mountain can emerge as swiftly as it disappeared, and when it is out only the distant curve of the earth can reduce its dominance, for it is the most arresting sight from forty million acres around. The Alaska Range elevates with a rapidity rare in the world. Its top is about two-thirds as high as the top of the Himalayas, but the Himalayan uplift is broad and extensive. If you were looking toward Mount Everest from forty miles away, you would lift your gaze only slightly to note the highest in a sea of peaks. Forty miles from McKinley you can stand at a bench mark of three hundred and climb with your eyes the other twenty thousand feet. The

14

The summit ramparts of Mount McKinley emerge from clouds 17,000 feet above these green hillsides.

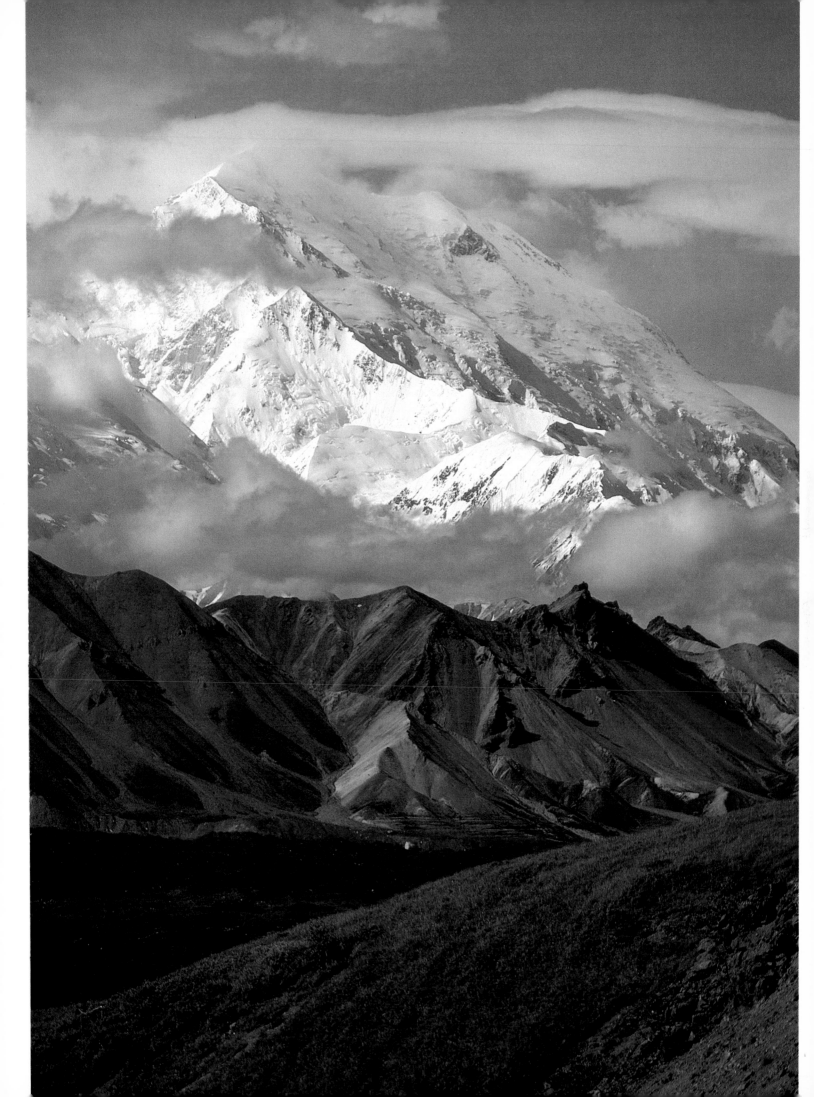

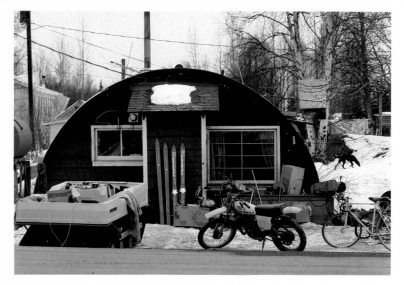

Bush pilot's residence, Talkeetna.

pilot named Cliff Hudson. Climbers stay in the Roadhouse – gather there, go over and over their gear, and wait for the mountain to come out, or, at least, for weather promising enough so that Hudson (among others) can fly them to the Kahiltna Glacier, on the mountain's south side, landing on skis at seven thousand feet. A gravel airstrip runs from behind Hudson's Quonset on out to the edge of the Susitna. I had once flown with him, not to the glacier but into the country around Talkeetna, looking for the dragon's teeth of capitals. Hudson will take anything that comes along – trappers and

miners to their cabins, hunters, Oriental alpinists. Bearded, bespectacled, with tousled thinning curly hair, Hudson flew in ten-inch boots and a brown wool shirt that had seen a lot of time on his back. In fact, he appeared to have been *in* the bush instead of flying it – to have lost his plane there and to have just walked out. In 1948, he had come to Alaska (from the Pacific "northwest") for all the great hunting and fishing, and he had become a bush pilot because it was "the only way you could get around." He was disappointed, bitterly, with Alaskan progress. Would he vote – now – for statehood? "Hell, no. They're ripping us off every way they can think of. It's bad enough just to have to *feed* all those politicians. We've got nine-tenths too many of them. They're a bunch of kids. It's just a big playpen – Juneau – at our expense. They argued once for eleven days over who would be the House Speaker." Flying me around the valley, bumping along on the wind over the spruce and the high tundra, he said he did not really care now if a capital were to come springing up from the land below. The plan was "ridiculous" and "expensive," but if a new city was to be built, it would be "O.K. anywhere."

All-terrain vehicle and puppy.

Talkeetna back yard.

Pioneer cabin, Talkeetna.

ALONG THE ROAD near Talkeetna, some years ago, the state sold off ground for something like a hundred and twenty-five dollars an acre. Five thousand dollars will buy such an acre now. Under the aspens and birches by the roadside, fresh signs appear beside the unbuilt gates of unbuilt subdivisions- SPORTSMAN ACRES, RUSTIC WILDERNESS, TIMBER PARK—and into the woods run new roads with earth plowed up to either side like banks of brown snow. Parka Parkway. Lichen Drive. Grizzly Way. The new capital is not the only fetal town in the Susitna Valley. Where the committee hovers, speculation hovers as well.

It can be worth your life to visit such a place. Nose a car in under the cottonwoods, have a look around. Before you can back out, a salesman has appeared from behind a tree and placed you under house arrest. He has a contract in his hand, and the lots are going fast. "No" is a word he does not comprehend. He tells you—erroneously—that the man who owned the computer firm in Anchorage that did the feasibility study for the Capital Site Selection Committee sold the computer firm and bought lots in this beautiful subdivision, and so did eight others in the same office. Hurry, buy a lot, you may be too late. This little beauty is almost two-thirds of an acre, and the price is fourteen thousand dollars. The distance to Anchorage is eighty miles, but the distance to the capital of Alaska will be a great deal less than that. Meanwhile, consider the view. The lot is on a high escarpment above the Susitna, and beyond the river are broad spruce and muskeg barrens and beyond them the white mountains. That big one on the right is McKinley. The Indians called it Denali, which meant "You'll be sorry if you don't sign now." Would you like to see some wildlife? Let's go down to the airstrip. Take you up and show you a moose. . . .

. . . Homesteaders—with their big (hundred-and-sixty-acre) blocks of land—stood to make or lose the most if the capital should settle near them. They could lose their remoteness, with

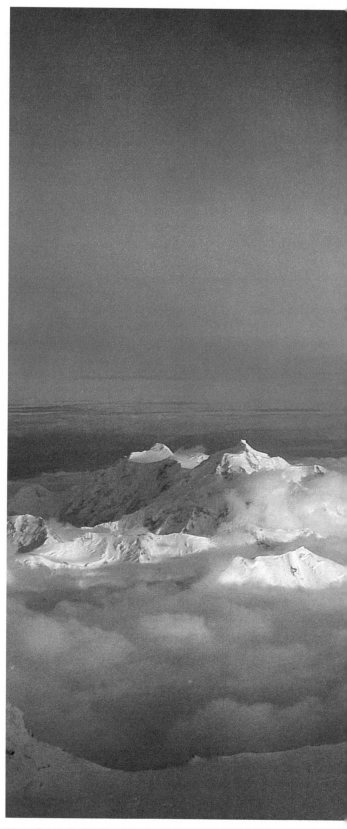

View from the high ground, Mount McKinley.

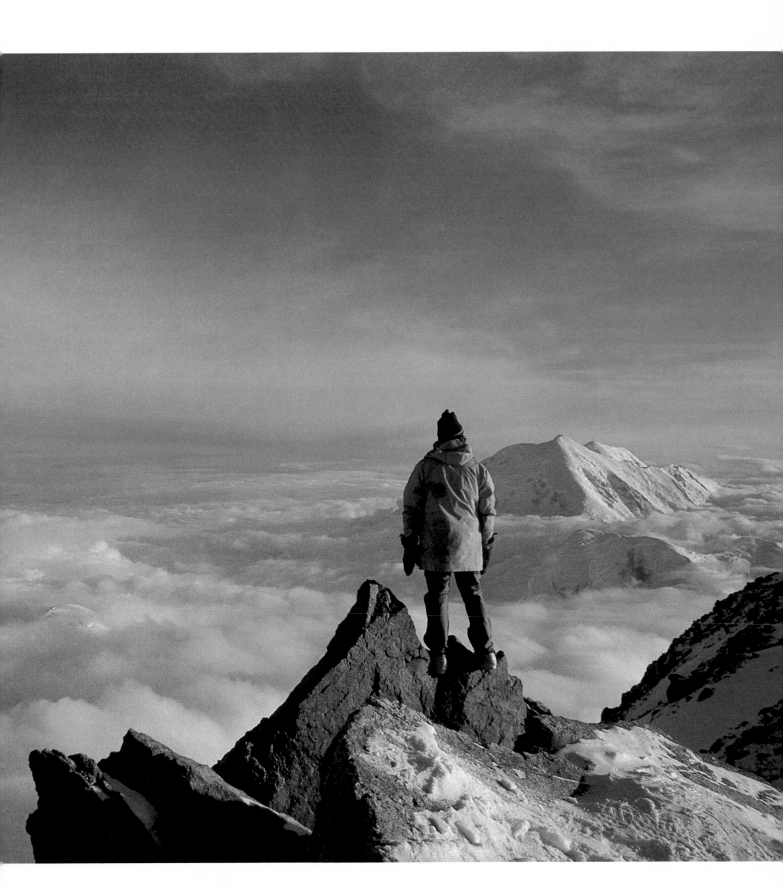

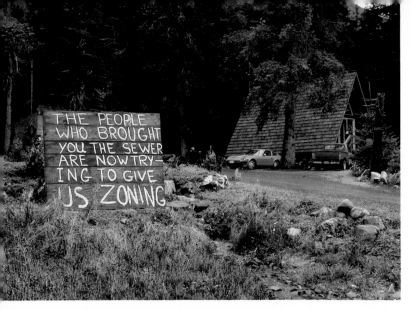

A homesteader's comment on creeping urbanization.

nowhere comparable to go; new homesteading in Alaska was shut off indefinitely in March, 1974. On the other hand, homesteaders in the Anchorage Bowl had sold out for many hundreds of thousands of dollars, and analogous deals might be offered in the Susitna Valley. Meanwhile, some homesteaders who had "proved up" on their land – that is, had lived on it for three years, built a habitable dwelling, and grown a crop on an eighth of the acreage – were already selling at prices that guessed the future. Only a few weeks before, a Susitna Valley homestead had sold for a hundred and forty-eight thousand dollars, and, like the ones we were flying over, it was many miles from the road.

A homestead on the highway system would be worth a great deal more than that. I had visited one, some miles south of Talkeetna, where a young couple, Don and Patty Bender, had moved onto the land in 1974 and had lived in a camper while they mixed concrete, poured a foundation,

Truck, Talkeetna. R.I.P.

and, together, built a house. It was a small, handsome place, with a steel-drum wood stove and big windows of insulated glass. Mount McKinley was framed in one window. Sometimes bears were too. Don Bender had a .300 Magnum but had not yet used it on a bear. He used it for his annual moose, and through the winter he and his wife ate mooseburgers, moose sausage, moose steak. They had eggs, too, and bacon coming. Near the house was an A-frame combination coop and sty. A pig lived in one end, chickens in the other. On cold nights, the chickens found a way to get near the pig. The Benders were in favor of the capital move. "Juneau is too inaccessible," he said. "Therefore, many of our politicians have hidden from their constituents." They did not want to lose their homestead, though, no matter how much its value might appreciate. They said they hoped the new capital would "not destroy our personal place of life." Their property, theirs for living on it, would probably be worth half a million dollars by the time it was proved up. If the capital came near, that sum could multiply, and the Benders would feel some pressure to change their minds.

They had so far cleared ten acres, in conformity with the rules – dense, closed-forest acres of spruce, birch, aspen – and had planted timothy and oats. Although the homestead was in the Susitna Valley, the terrain was rough with sheer-sided hillocks, and the Benders' ten acres under cultivation looked less like a field than a bald lumpy spot on a high mountainside, the crops clinging to serpentine contours. The appearance of it all tended to suggest mockery of the Homestead Act, which was written to offer farmland to an expanding nation, and this minimal "farm" had been hacked absurdly from a steep subarctic forest. The Homestead Act, though, had a venerable history of mocking itself. It had worked well only east of the hundredth meridian, where there was enough rain to serve a farm, and homesteads in the range country and semideserts of the West had made, if anything, less sense that the homesteads of Alaska. In general, the Alaskan climate

is not much more severe than the climate of, say, Montana, and the soil under Alaskan cottonwoods could be richly supportive of crops. The growing season is not prohibitively short – roughly mid-May to the first of September – and in various fruits and vegetables sugar content will build up to unusual levels in the cool air and the long northern light. A potato developed by Curtis Dearborn, at the University of Alaska's experimental farm in the Matanuska Valley, is eleven per cent sugar and can be eaten like an apple. Dearborn also developed the Alaska Frostless Potato, which survives frosting at twenty-seven degrees. Potatoes could be farmed very successfully as far north as the Yukon, and may be some-

day, if the idea ever takes hold. Agriculture, though, is among Alaska's foremost undeveloped assets. There is a so-called "farm loop" north of Fairbanks, with broad cleared fields and haystacks under tarps – a Pennsylvanian scene, reminiscent of the mother country. Rampant subdivisions, of late, have been eating it up. The Trans-Alaska Pipeline winds among the farms. In the Matanuska Valley, which forms a V with the Susitna Valley around the Talkeetna Mountains, the soil – loess soil – has the color and consistency of Hershey's cocoa and is rockless two feet down. Farmers from the Middle West were brought to the Matanuska Valley during the Depression and, after a disorganized beginning, established suc-

ount McKinley and the Talkeetna Road on a morning in late winter.

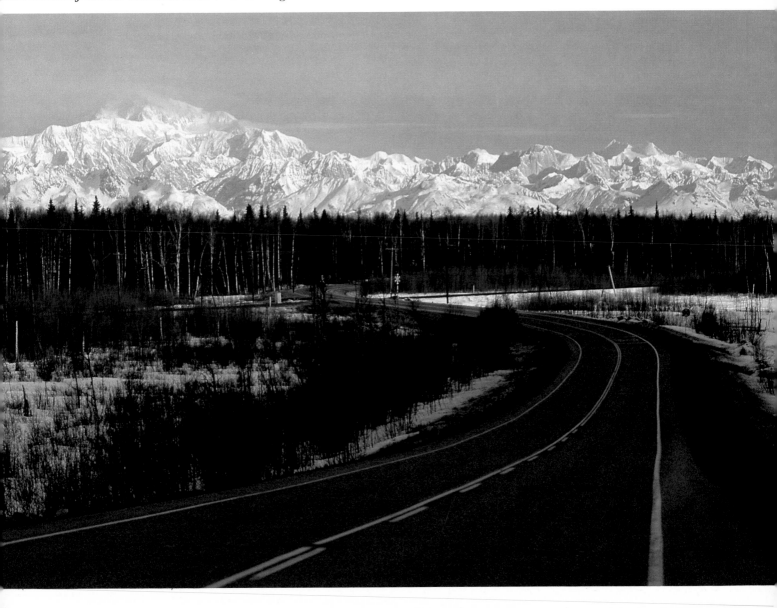

cessful farms. In many parts of the valley are fields and gambrel-roofed barns, with the Chugach Mountains rising to alpine snowfields beyond—a phenomenal sight from a farm. Matanuska notwithstanding, of arable Alaska not much is plowed—far too little to be expressed as a percentage. As Alaskan land, in huge segments, is divided up for various purposes, agriculture fails to make the list. But the strawberries are delicious enough to make you drunk—Susitnas, Talkeetnas, Matareds. You can grow carrots, beets, spinach, broccoli, rhubarb, cauliflower, Brussel sprouts, zucchini—all in the heart of Alaska—and wheat, barley, alfalfa, oats, and white sweet clover eight feet high. Peas are particularly sweet and aromatic. There is virtually no need for pesticides. Cabbages grow to be two feet in diameter and can weigh seventy pounds. They look like medicine balls. If Alaska would get up off its past (the boom philosophy), it could be the world center of sauerkraut-cabbage production. That sounds

laughable, but the state might come out of it economically sound. The new capital city could be sterile and governmental and given to one purpose, or it could be an island in a sea of farms—the state of Alaska, from one end to the other, being green about half the year.

Exceptions are glaciers, but they are only three per cent of Alaska—the big ones close to the gulf coastline, which reaches down and east from Anchorage toward Cordova, Yakutat, Haines, and Juneau. Something like seventeen thousand square miles are permanently under ice, while the rest of Alaska melts. Ninety-seven per cent—half a million square miles—melts. Even the great ice sheets of the glacial ages did not cover Alaska. An arm of the Laurentide covered the Brooks Range. The Cordilleran Glacier Complex, which covered the Canadian Rockies and the chains of the Pacific coast, reached out over the Alaska Range and across all the land between the mountains and the gulf. But the Interior and the

Farm in the Matanuska Valley, under peaks of the Chugach Range.

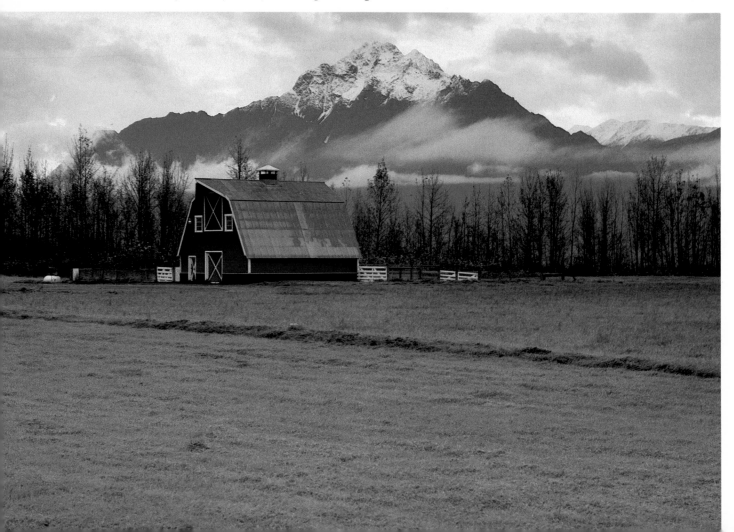

Arctic Slope and all the west coast were bare. While much of New Jersey was covered with ice, most of Alaska was not.

The truly immense glaciers might be down in the southeast, but the glacier that was off to our right just now was in no sense modest. The helicopter had crossed Shulin Lake, and had circled it, tilting far over so the committee members could hang by their seat belts for a plan view, its big rotor blades biting the air with the sound of a working axe. Level again, it was proceeding west toward the Kahiltna River, the source of which, off to the north, was almost as preëminent as the mountains above. It came down out of the Alaska Range like a great white tongue. It came—the Kahiltna Glacier—from eleven thousand feet, from a high saddle between the peaks of Foraker and McKinley. And two, three, four miles wide all the way, it flowed fifty miles south into the valley, where it finally turned into river at an altitude of scarcely a thousand feet. This was the big glacier

the climbers land on—and the fact that they land at the seven-thousand-foot contour has nothing to do with the strategies of the sport. They do so because airplanes are not permitted to land in Mount McKinley National Park, and the park boundary happens to cross the glacier at that level. The river below us was the product of the sun, and even in autumn and from the helicopter's high perspective it was awesome to see. Most fast rivers are white, smooth, white, smooth—alternating pools and rapids. This one was white all the way, bank to bank, tumultuous, torrential, great rushing outwash of the Alaska Range. With so many standing waves, so much white water, it appeared to be filled with running sheep. The color of the water, where it was flat enough to show, was actually greenish-gray, and its clarity was nil. It carried so much of what had been mountains. Glacier milk, as it is called, contains a high proportion of powdered rock, from pieces broken off and then ground by the ice. The colors

Open crevasses on the Kahiltna Glacier dwarf a ski plane about to land.

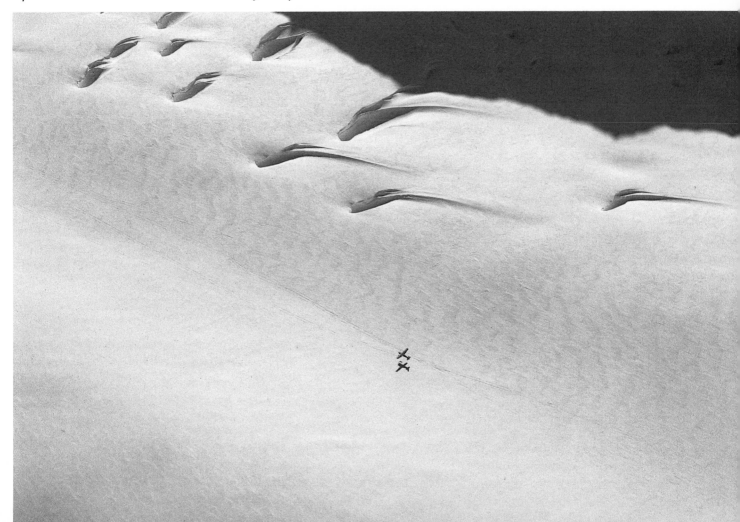

Frozen lakelets on the lower Ruth Glacier.

of outwash rivers are determined by the diets of the glaciers—schist, gneiss, limestone, shale.

Glacial erratics were all over the valley, and there was one below us now. The ice in the past had nosed southward these huge monoliths—supermagnified boulders—which had rafted along on the advancing terminus and had not become caught and ground. The one beneath us appeared to be as large as a three-story building, weirdly standing in the forest. It was so big that soil had formed on its upper surface, and trees grew from it like hair.

We crossed Lake Creek, which was not a glacial stream and was running so clear we could see its gravels. Ahead was Mount Yenlo, a four-thousand-foot rise in the western Susitna Valley, and the helicopter set down there, on a southerly slope of the mountain, to release the committee. Just below, and beside the clear stream, was the most remote site under consideration for the capital—thirty-five miles from the highway and undeniably as beautiful a setting as could possibly exist in the valley. It was high grassland—under, but approaching, a thousand feet—with white birches and white spruce scattered through it, big trees for this part of the world, almost a foot in diameter. The mean January temperature was ten degrees, July fifty-six. The summit of Yenlo was above the site, to the immediate northwest, and due north, close across fifty miles, was the palpable McKinley. The committee spread out through berry fields, these laced with stands of fern. There was sign of moose and caribou. There were depressions in the grass where bears had slept.

Ice and fall color, Matanuska Glacier.

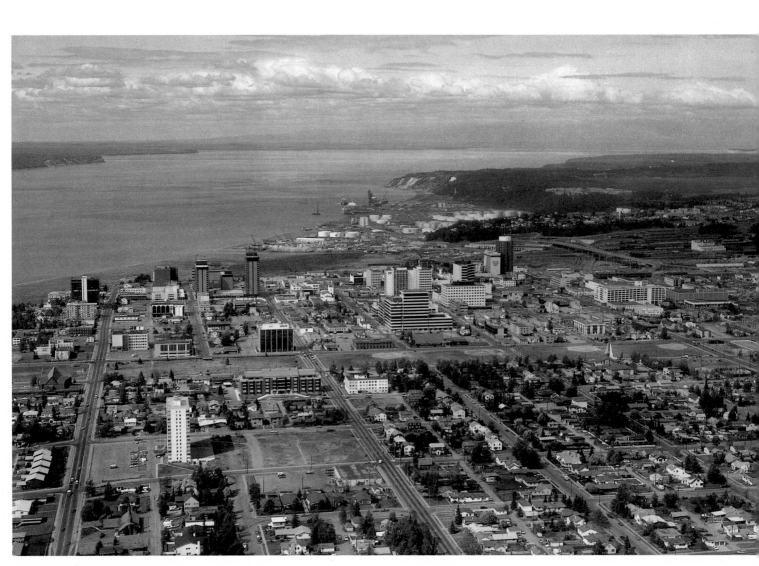

Downtown Anchorage from the air.

T HERE ARE THOSE who would say that tens of thousands of barrels of oil erupting from a break in the Trans-Alaska Pipeline would be the lesser accident if, at more or less the same time, a fresh Anchorage were to spill into the bush. While the dream of the capital city plays on in the mind, Anchorage stands real. It is the central hive of human Alaska, and in manner and structure it represents, for all to see, the Alaskan dynamic and the Alaskan aesthetic. It is a tangible expression of certain Alaskans' regard for Alaska–their one true city, the exemplar of the predilections of the people in creating improvements over the land.

As may befit a region where both short and long travel is generally by air, nearly every street in Anchorage seems to be the road to the airport. Dense groves of plastic stand on either side– flashing, whirling, flaky. HOOSIER BUDDY'S MOBILE HOMES. WINNEBAGO SALES & SERVICE. DISCOUNT LIQUORS OPEN SUNDAY. GOLD RUSH AUTO SALES. PROMPT ACTION LOCKSMITHS. ALASKA REFRIGERATION & AIR CONDITION. DENALI FUEL . . .

"Are the liquor stores really open Sundays?"

"Everything in Anchorage is open that pays."

Almost all Americans would recognize Anchorage, because Anchorage is that part of any city where the city has burst its seams and extruded Colonel Sanders.

"You can taste the greed in the air."

BELUGA ASPHALT.

Anchorage is sometimes excused in the name of pioneering. Build now, civilize later. But Anchorage is not a frontier town. It is virtually unrelated to its environment. It has come in on the wind, an American spore. A large cookie cutter brought down on El Paso could lift something like Anchorage into the air. Anchorage is the northern rim of Trenton, the center of Oxnard, the ocean-blind precincts of Daytona Beach. It is condensed, instant Albuquerque.

PANCHO'S VILLA, MEXICAN FOOD. BULL SHED, STEAK HOUSE AND SONIC LOUNGE.

SHAKEY'S DRIVE-IN PIZZA. EAT ME SUBMARINES.

Anchorage has developed a high-rise city core, with glass-box offices for the oil companies, and tall Miamian hotels. Zonelessly lurching outward, it has made of its suburbs a carnival of cinder block, all with a speculative mania so rife that sellers of small homesites–of modest lots scarcely large enough for houses–retain subsurface rights. In vacant lots, queen-post trusses lie waiting for new buildings to jump up beneath them. Roads are rubbled, ponded with chuckholes. Big trucks, graders, loaders, make the prevailing noise, the dancing fumes, the frenetic beat of the town. Huge rubber tires are strewn about like quoits, ever ready for the big machines that move hills of earth and gravel into inconvenient lakes, which become new ground.

FOR LEASE. WILL BUILD TO SUIT.

Anchorage coins millionaires in speculative real estate. Some are young. The median age in Anchorage is under twenty-four. Every three or four years, something like half the population turns over. And with thirty days of residence, you can vote as an Alaskan.

POLAR REALTY. IDLE WHEELS TRAILER PARK. MOTEL MUSH INN.

Anchorage has a thin history. Something of a precursor of the modern pipeline camps, it began in 1914 as a collection of tents pitched to shelter workers building the Alaska Railroad. For decades, it was a wooden-sidewalked, gravel-streeted town. Then, remarkably early, as cities go, it developed an urban slum, and both homes and commerce began to abandon its core. The exodus was so rapid that the central business district never wholly consolidated, and downtown Anchorage is even more miscellaneous than outlying parts of the city. There is, for example, a huge J. C. Penney department store filling several blocks in the heart of town, with an interior mall of boutiques and restaurants and a certain degree of chic. A couple of weedy vacant lots separate this

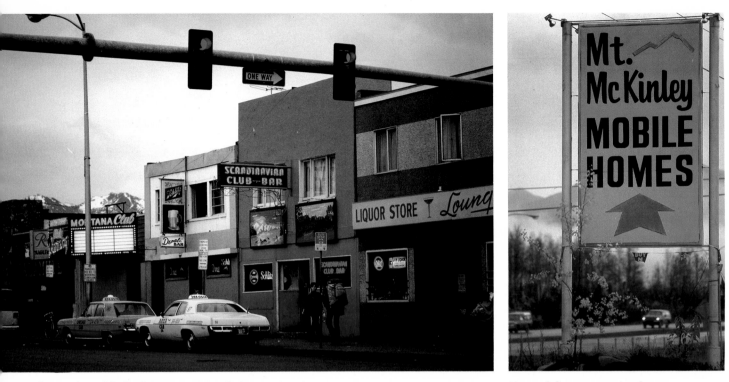

Anchorage's red-light district on Fourth Avenue.

Sign of the times in Anchorage.

complex from five log cabins. Downtown Anchorage from a distance displays an upreaching skyline that implies great pressure for land. Down below, among the high buildings, are houses, huts, vegetable gardens, and bungalows with tidy front lawns. Anchorage burst out of itself and left these incongruities in the center, and for me they are the most appealing sights in Anchorage. Up against a downtown office building I have seen cordwood stacked for winter.

In its headlong, violent expansion, Anchorage had considerable, but not unlimited, space to fill. To an extent unusual among cities, Anchorage has certain absolute boundaries, and in that sense its growth has been a confined explosion. To the north, a pair of military bases establish, in effect, a Roman wall. To the west and south, fjordlike arms of the Pacific–Knik Arm, Turnagain Arm–frame the city. Behind Anchorage, east, stand the Chugach Mountains, stunning against the morning and in the evening light–Mount Magnificent,

Mount Gordon Lyon, Temptation Peak, Tanaina Peak, Wolverine Peak, the Suicide Peaks. Development has gone to some extent upward there. Houses are pushpinned to the mountainsides–a Los Angelized setting, particularly at night, above the starry lights of town. But the mountains are essentially a full stop to Anchorage, and Anchorage has nowhere else to go.

Within this frame of mountains, ocean, and military boundaries are about fifty thousand acres (roughly the amount of land sought by the Capital Site Selection Committee), and the whole of it is known as the Anchorage Bowl. The ground itself consists of silt, alluvium, eolian sands, glacial debris–material easy to rearrange. The surface was once lumpy with small knolls. As people and their businesses began filling the bowl, they went first to the knolls, because the knolls were wooded and well drained. They cut down the trees, truncated the hills, and bestudded them with buildings. They strung utility lines like baling wire

30

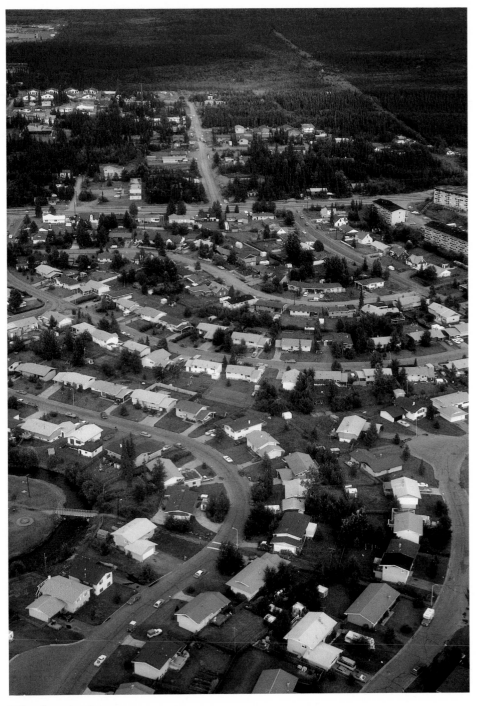

Suburban Anchorage.

Private planes tied down behind homes on the outskirts of Anchorage.

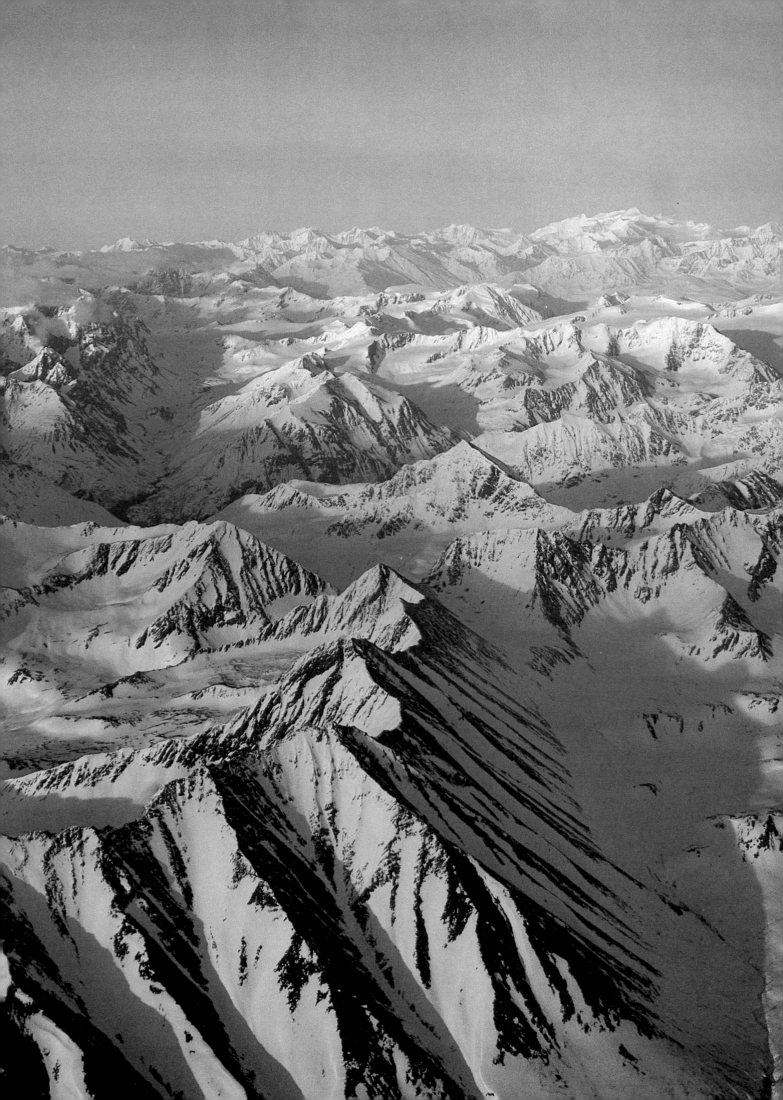

from knoll to knoll. The new subdivisions within the bowl were thus hither and yon, random, punctuated with bogs. Anchorage grew like mold.

WOLVERINE ALUMINUM SIDING. ALASKA FOUR-WHEEL DRIVE. JACK BENNY'S RADIO-DISPATCHED CESSPOOL PUMPING.

Low ground is gradually being filled. The bowl has about a hundred and eighty thousand people now, or almost half of human Alaska. There are some in town—notably, Robert Atwood, of the *Times*—who would like to see Anchorage grow to seven hundred thousand. Atwood is a big, friendly, old-football-tackle sort of man, with whitening hair and gold-rimmed glasses. Forty years on the inside, this impatient advocate of the commercial potentialities of Alaska is said to be one of the two wealthiest people in the state, the other being his brother-in-law. "Idealists here in town see a need for a park in every housing development," Atwood told me one day. "They want to bury utility lines, reserve green belts, build bicycle paths. With these things, the bowl could only contain three hundred and fifty thousand. They're making it very difficult for man, these people. They favor animals, trees, water, flowers. Who ever makes a plan for man? Who ever *will* make a plan for man? That is what *I* wonder. I am known among conservationists as a bad guy."

In Anchorage, if you threw a pebble into a crowd, chances are you would not hit a conservationist, an ecophile, a wilderness preserver. In small ghettos, they are there—living in a situation lined with irony. They are in Alaska—many of them working for the federal government—because Alaska is everything wild it has ever been said to be. Alaska runs off the edge of the imagination, with its tracklessness, its beyond-the-ridge-line surprises, its hundreds of millions of acres of wilderness—this so-called "last frontier," which is certainly all of that, yet for the most part is not a frontier at all but immemorial landscape in an all but unapproached state. Within such vastness, Anchorage is a mere pustule, a dot, a minim—a walled city, wild as Yonkers, with the wildlife

riding in a hundred and ninety-three thousand trucks and cars. Yet the city—where people are, where offices are—is perforce the home address of wilderness planners, of wildlife biologists, of Brooks Range guides.

The first few days I spent in Alaska were spent in Anchorage, and I remember the increasing sense of entrapment we felt (my wife was with me), knowing that nothing less than a sixth of the entire United States, and almost all of it wilderness, was out there beyond seeing, while immediate needs and chores to do were keeping us penned in this portable Passaic. Finally, we couldn't take it any longer, and we cancelled appointments and rented a car and revved it up for an attempted breakout from town. A float plane—at a hundred and ten dollars an hour—would have been the best means, but, like most of the inmates of Anchorage, we could not afford it. For a great many residents, Anchorage is about all they ever see of Alaska, day after day after year. There are only two escape routes—a road north, a road south—and these are encumbered with traffic and, for some miles anyway, lined with detritus from Anchorage. We went south, that first time, and eventually east, along a fjord that would improve Norway. Then the road turned south again, into the mountains of Kenai—great tundra balds that reminded me of Scotland and

Red fox and purple fireweed.

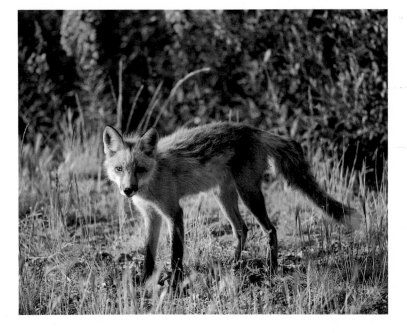

Peaks and ridges of the Chugach Range.

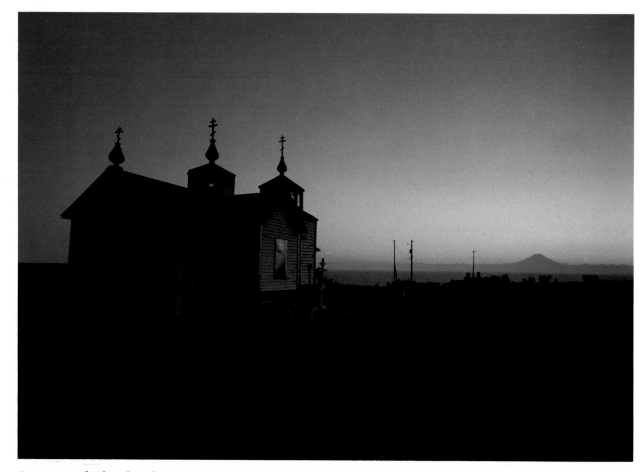

Russian Orthodox church, Kenai Peninsula

my wife of parts of Switzerland, where she had lived. She added that she thought these mountains looked better than the ones in Europe. Sockeyes, as red as cardinals, were spawning in clear, shallow streams, and we ate our cheese and chocolate in a high meadow over a torrential river of green and white water. We looked up to the ridges for Dall sheep, and felt, for the moment, about as free. Anchorage shrank into perspective. It might be a sorry town, but it has the greatest out-of-town any town has ever had.

BIG RED'S FLYING SERVICE. BELUGA STEAM & ELECTRIC THAWING. DON'T GO TO JAIL LET FRED GO YOUR BAIL.

There is a street in Anchorage—a green-lights, red-lights, busy street—that is used by auto-

mobiles and airplanes. I remember an airplane in someone's driveway—next door to the house where I was staying. The neighbor started up its engine one night toward eleven o'clock, and for twenty minutes he ran it flat out while his two sons, leaning hard into the stabilizers, strained to hold back the plane. In Alaska, you do what you feel like doing, or so goes an Alaskan creed.

There is, in Anchorage, a somewhat Sutton Place. It is an enclave, actually, with several roads, off the western end of Northern Lights Boulevard, which is a principal Anchorage thoroughfare, a neon borealis. Walter Hickel lives in the enclave, on Loussac Drive, which winds between curbs and lawns, neatly trimmed, laid out, and landscaped, under white birches and

34

balsam poplars. Hickel's is a heavy, substantial home, its style American Dentist. The neighbors' houses are equally expensive and much the same. The whole neighborhood seems to be struggling to remember Scarsdale. But not to find Alaska.

I had breakfast one morning in Anchorage with a man who had come to Alaska from The Trust for Public Land, an organization whose goal is to buy potential parkland in urban areas and hold it until the government, whose legislative machinery is often too slow for the land market, can get up the funds for the purpose. In overbuilt urban settings—from Watts to Newark and back to Oakland—The Trust for Public Land will acquire whatever it can, even buildings under demolishment, in order to create small parks and gardens that might relieve the compressed masses. And now The Trust for Public Land had felt the need to come to Anchorage—to the principal city of Alaska—to help hold a pond or a patch of green for the people in the future to have and see.

Books were selling in Anchorage, once when I was there, for forty-seven cents a pound.

There are those who would say that the only proper place for a new capital of Alaska—if there has to be a new one—is Anchorage, because anyone who has built a city like Anchorage should not be permitted to build one anywhere else.

At Anchorage International Airport, there is a large aerial photograph of Anchorage formed by pasting together a set of pictures that were made without what cartographers call ground control. This great aerial map is one of the first things to confront visitors from everywhere in the world, and in bold letters it is titled "ANCHORAGE, ALASKA. UNCONTROLLED MOSAIC."

35

Mount McKinley from Nugget Pond, Camp Denali.

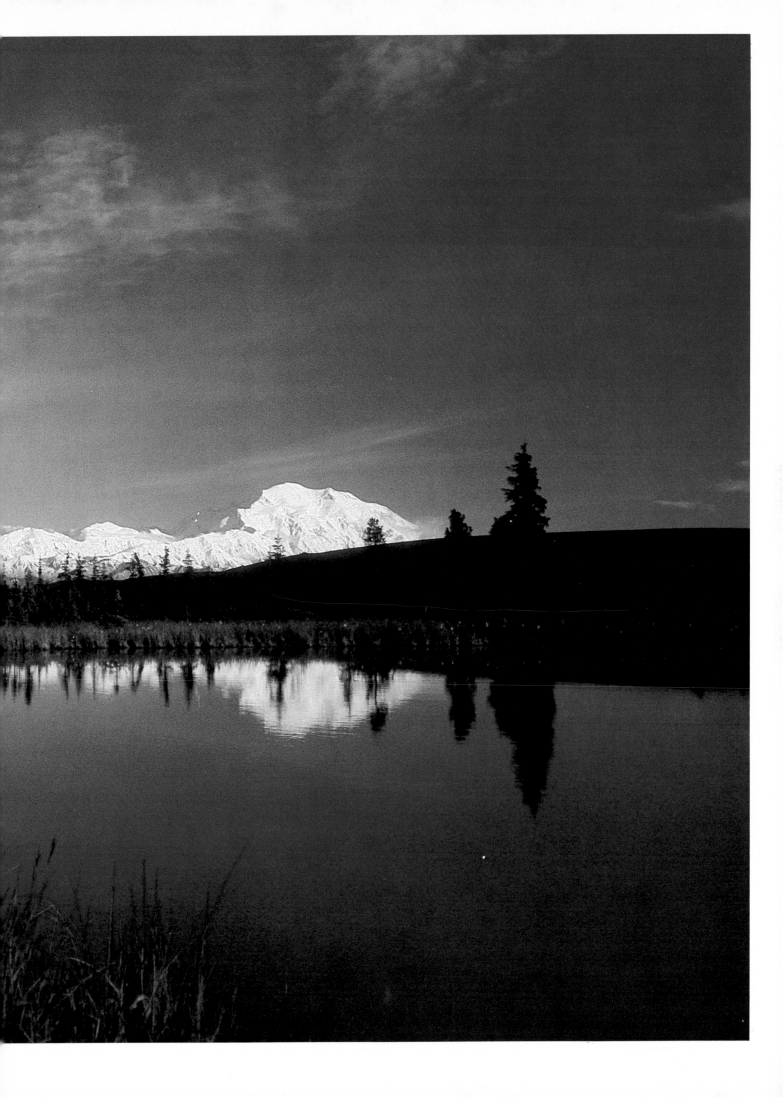

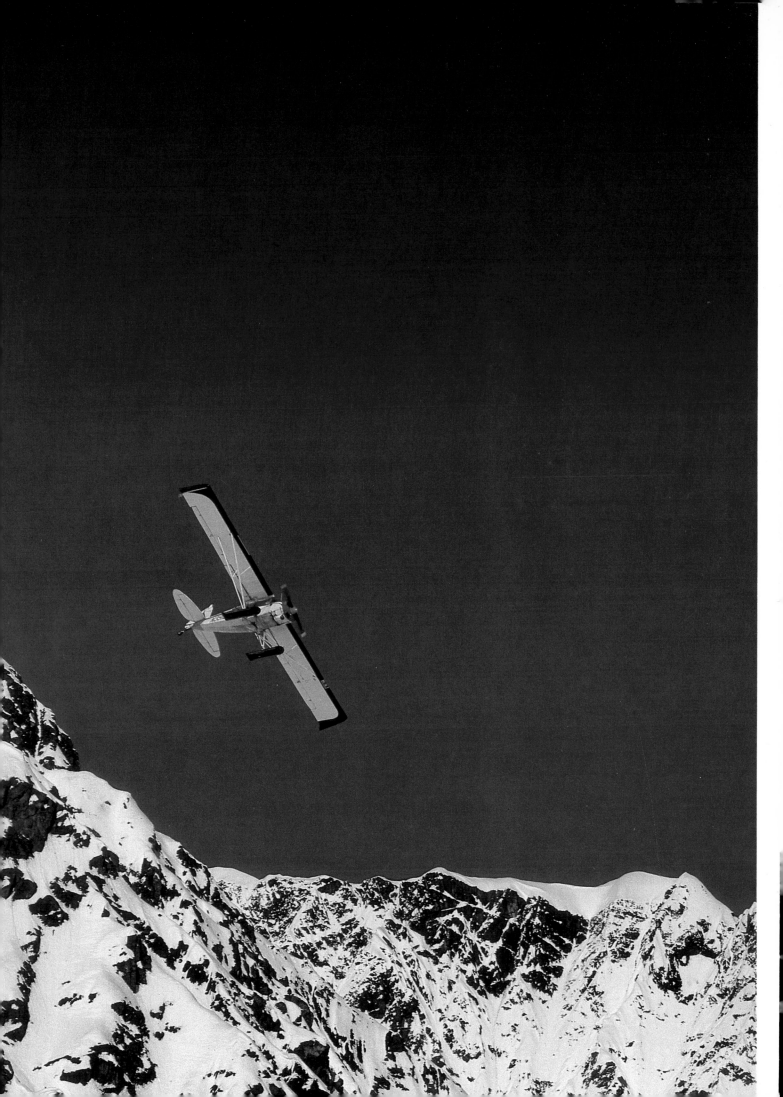

THERE ARE no geographical requirements for pilots in the United States. Anyone who is certified as a pilot can fly anywhere, and that, of course, includes anywhere in Alaska. New pilots arrive steadily from all over the Lower Forty-eight. Some are attracted by the romance of Alaska, some by the money around the pipeline. The Alyeska Pipeline Service Company, soon after it began its construction operations, set up its own standards for charter pilots who would fly its personnel—standards somewhat stiffer than those of the Federal Aviation Administration. Among other things, Alyeska insisted that applicants without flying experience in Alaska had to have fifty hours of documented training there, including a line check above the terrain they would be flying.

One effect of the pipeline charters has been to siphon off pilots from elsewhere in the Alaskan bush. These pilots are often replaced by pilots inexperienced in Alaska. Say a mail pilot quits and goes off to fly the pipeline. His replacement might be three days out of Teterboro. The mail must go through. Passengers in such planes (passengers ride with bush mail) sometimes intuit that they and the pilot are each seeing the landscape in a novel way. Once, for example, in the eastern-Alaska interior, I rode in a mail plane that took off from Fairbanks to fly a couple of hundred miles across mountains to Eagle, a village on the upper Yukon. It was a blustery, wet morning, and clouds were lower by far than summits. As rain whipped against the windshield, visibility forward was zero. Looking down to the side, the pilot watched the ground below—trying to identify various drainages and pick his way through the mountains. He frequently referred to a map. The plane was a single-engine Cessna 207 Skywagon, bumping hard on the wind. We went up a small tributary and over a pass, where we picked up another river and followed it downstream. After a time, the pilot turned around and went many miles back in the direction from which he had come. He explored another tributary. Then, abruptly, he

turned again. The weather was not improving. Soon his confidence in his reading of the land seemed to run out altogether. He asked in what direction the stream below was flowing. He could not tell by the set of the rapids. He handed the map to a passenger who had apparently visited the region once or twice before. The passenger read the map for a while and then counselled the pilot to stay with the principal stream in sight. He indicated to the pilot which direction was down-hill. At length, the Yukon came into view. I, who love rivers, have never felt such affection for a river. One would not have to be Marco Polo to figure out now which way to go. I had been chew-

A pilot brushes the snow from his plane's wings during a pre-flight check.

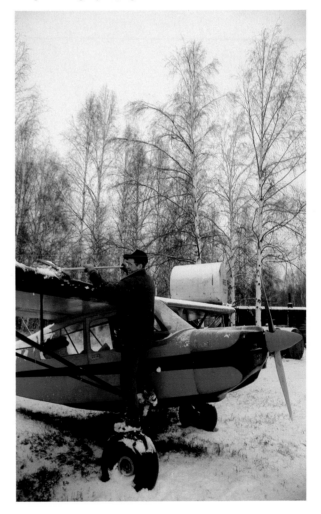

Piper Supercub skirting ridge tops in the Alaska Range.

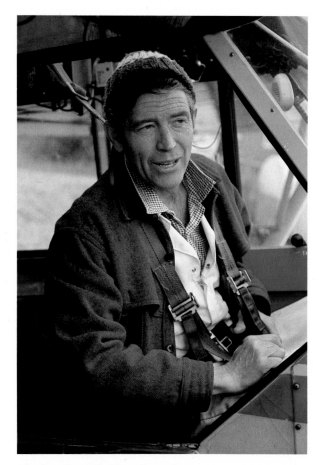

The late Don Sheldon, legendary
glacier pilot of Talkeetna.

ing gum so vigorously that the hinges of my jaws would ache for two days. We flew up the Yukon to Eagle. When we landed, a young woman with a pickup was waiting to collect the mail. As the pilot stepped out, she came up to him and said, "Hello. You're new, aren't you? My name is Anna."

That was a scheduled flight on an American domestic airline. The company was Air North, which serves many bush communities, and its advertising slogan was "Experience Counts." Another Air North pilot told me once that he liked being a bush pilot in Alaska—he had arrived from New York several months before—but he was having a hard time living on his pay. He said there was better money to be made operating bulldozers on the pipeline than operating planes for Air North. As a result, experienced, able pilots had not only

been drawn away to fly pipeline charters; experienced, able pilots were also flying bulldozers on the tundra.

Some people I know in the National Park Service who were studying a region near the upper Yukon chartered a helicopter in an attempt to find the headwaters of a certain tributary stream. When they had been in flight for some time and had not seen anything remotely resembling the terrain they were looking for, they grew uneasy. When they looked ahead and saw the bright-white high-rising Wrangells, mountain peaks two hundred miles from where they were going, they realized they were lost. The pilot, new in Alaska, was from Alabama. "This is different, unique, tough country," a pilot from Sitka once told me. "A guy has to know what he's doing. Flying is a way of life up here, and you have to get used to it. You can't drive. You can't walk. You can't swim."

In Anchorage, John Kauffmann had introduced me to his friend Charlie Allen, a general freelance bush pilot with a wide reputation for having no betters and few peers. From the Southeastern Archipelago to Arctic Alaska, Allen had been flying for twenty-five years. He was dismayed by the incompetence of some people in his profession, and was not at all shy to say so. "Alaska is the land of the bush pilot," he said. "You have to think highly of this bush pilot, because he's dirty, he has a ratty airplane, and he's alive. It's a myth, the bush-pilot thing. It's 'Smilin' Jack.' The myth affects pilots. Some of them, in this magic Eddie Rickenbacker fraternity, are more afraid of being embarrassed than they are of death. Suppose they're low on gas. They're so afraid of being embarrassed they keep going until they have no recourse but to crash. They drive their aircraft till they cough and quit. Kamikaze pilots. That's what we've got up here—kamikaze pilots from New Jersey. Do you think one of them would ever decide the weather's too tough? His champion-aviator's manhood would be impugned. Meanwhile, he's a hero if he gets through. A while ago, some guy ran out of gas at night on the ice pack.

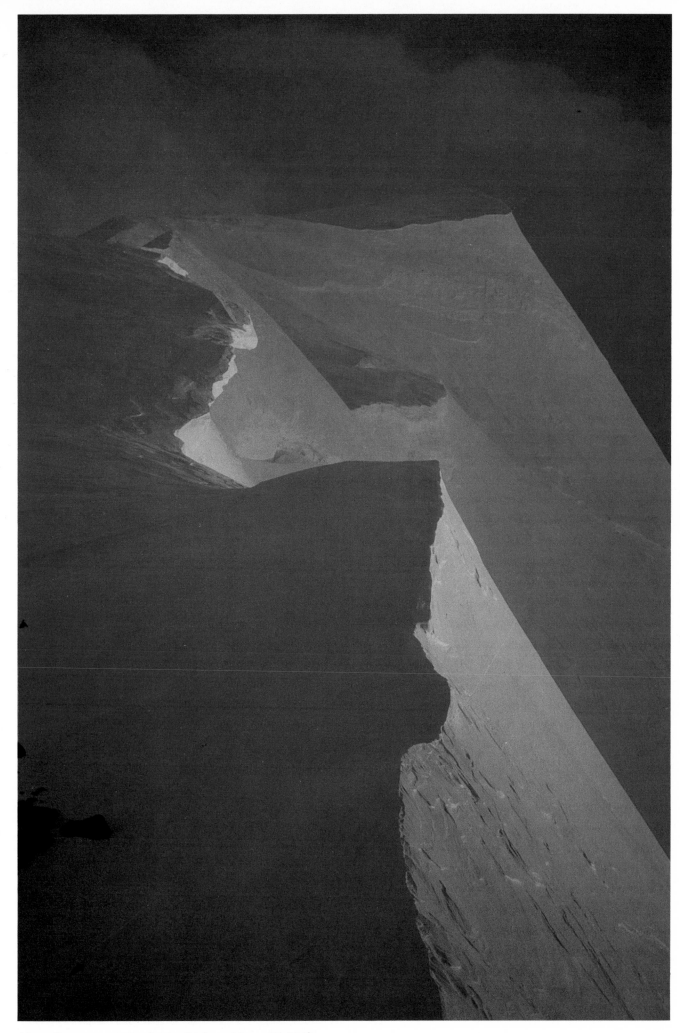

Alpenglow on a corniced ridge high on Mount McKinley.

He had been chartered for a polar-bear hunt. He chopped off his fuel tanks with an axe and used the fuel tanks as boats. He and the hunters paddled out. He was then regarded as a hero. He was regarded as Eddie Rickenbacker *and* Smilin' Jack But he was guilty of outrageous technical behavior. He was the fool who got them into the situation in the first place.

"Aircraft-salvage operators have a backlog of planes waiting to be salvaged in Alaska. Helicopters go out for them. In the past year and a half, I have helped salvage six planes that have been wrecked by *one* pilot. Don't identify him. Just call him 'a government employee.' Why do passengers *go* with such pilots? Would they go to the moon with an astronaut who did not have round-trip fuel? If you were in San Francisco and the boat to Maui was leaking and the rats were leaving, even if you had a ticket you *would not go*. Safety in the air is where you find it. Proper navigation helps, but proper judgment takes care of all conditions. You say to yourself, 'I ain't going to go today. The situation is too much for me.' And you resist all pressure to the contrary."

Allen paused a moment. Then he said, "You don't have to run into a mountain. Only a pilot is needed to wreck an airplane."

Of reported accidents, there have lately been something like two hundred a year in Alaska. Upwards of twenty-five a year produce fatal injuries, killing various numbers of people. Another fifteen crashes or so produce injuries rated "serious." The figures seem to compliment the pilots in a state where a higher percentage of people fly—and fly more often—than they do anywhere else in the United States. Merrill Field, a light-plane airfield in Anchorage, handles fifty-four thousand more flights per year than Newark International. On the other hand, if you get into an airplane in Alaska your chances of not coming back are greater by far than they would be in any other part of the country. Only Texas and California, with their vastly larger populations, consistently exceed Alaska in aircraft accidents. Gov-

ernment employees in Alaska speak of colleagues who have been lost "in line of duty." In air accidents during the past two years, the Bureau of Land Management has lost four, Alaska Fish and Game has lost one, U.S. Fish and Wildlife has lost three, the U.S. Forest Service has lost five, and the National Park Service has lost seven (in a single crash). A gallery of thirteen of the great bush pilots in the history of Alaska was presented in an Alaska newspaper not long ago. Of the thirteen, ten—among them Carl Eielson, Russ Merrill, Haakon Christensen, Big Money Monsen—died flying. I dropped in at a bar one day, in a small Alaskan town, where a bush pilot had one end of a plastic swizzlestick clamped between his teeth and was attempting to stretch it by pulling the other end. He had apparently been there some time, and he was challenging all comers to see who could stretch a swizzlestick the farthest. Jay Hammond, governor of Alaska, was himself a bush pilot for twenty-eight years, and a conspicuously good one. In an interview with him, I mentioned the sorts of things that cause disgust in pilots like Charlie Allen, and Hammond said, "There is nothing you can do by statute to assure competence." I wondered if that was altogether true—if, at the very least, regulations such as Alyeska's regarding pilots who come in from outside could not be extended to the state at large.

All this applies, of course, only to bush pilots and not to the big jet-flying commercial carriers, whose accidents are extremely rare and are not outstanding in national statistics. As we flew from Fairbanks to Kotzebue to begin the trip to the Salmon River, we were in a Boeing 737 of Wien Air Alaska. One Captain Clayton came on the horn and said he would be pleased to play the harmonica for us as soon as he had finished a Fig Newton. A while later, he announced that his mouth was now solvent—and, above clouds, he began to play. He played beautifully. The speaker system in that particular aircraft seemed to have been wired especially to meet his talent. He played three selections, and he found Kotzebue.

Aerial view of a corner of Augustine Island, newly green just three years after a major volcanic eruption in 1976. In the distance are the mountains of Katmai National Monument.

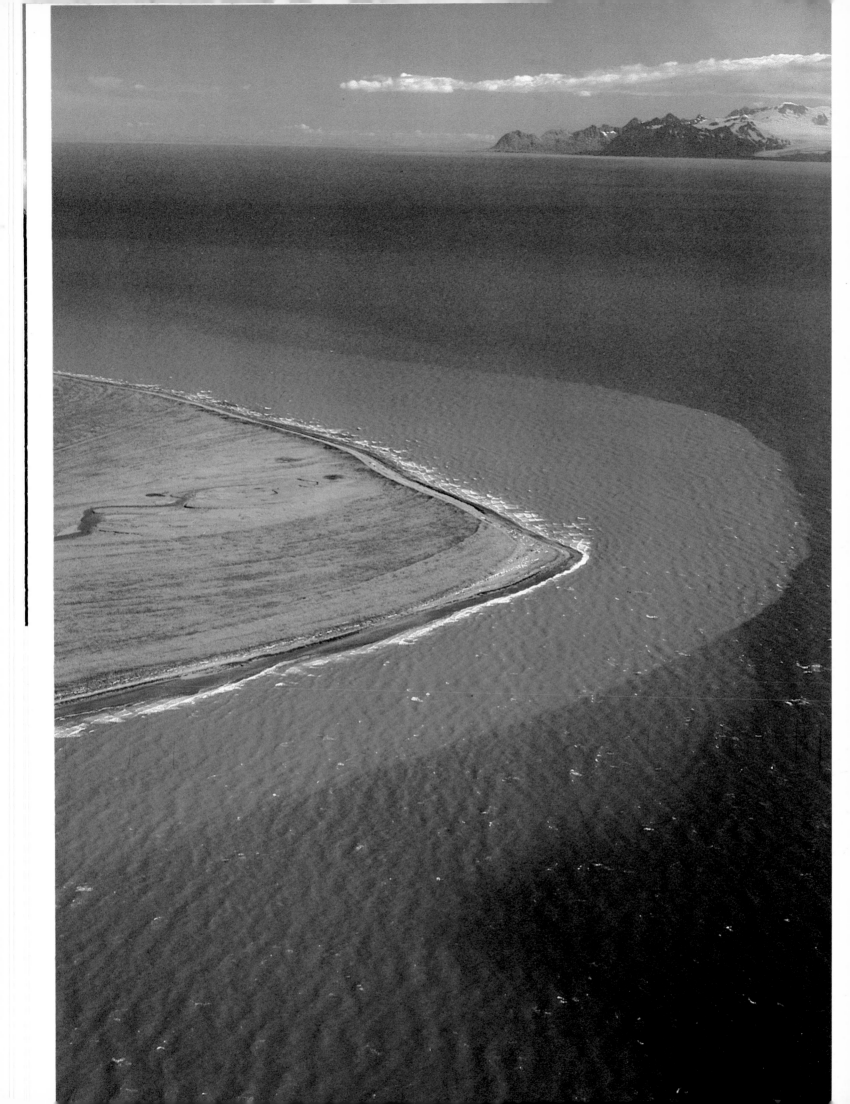

they rendezvoused—each to see that the other was all right, and to pass on information. This was total wilderness. They were something over a hundred miles from Circle and eighty from Eagle and eighty from Big Delta, where the Nelsons lived at the time. In any kind of need, there was nowhere else to go. In discrete valleys were a few cabins, and they stayed in them or siwashed (camped on the trail). When they were picked up—after three months in there, generally apart and alone—they had collected a good share of their income for the following year.

THE NELSONS' PLACE is landscaped only by its woods. Neat, odd, it lacks the expectable outdoor furnishings of an Alaskan cabin. My side of the road makes up for that. A few feet away from me, in the direction of the center of town, is the cabin of Dale and Gloria Richert, who sell used snow machines, washing machines, sleds—examples of which are strewn about the space between the cabin and the road. The cabin is roofed with slit and flattened fuel cans. Richert had a store in Michigan not long ago. It was firebombed by hoodlums. This helped him decide that an appropriate community in which to seek a new life might be somewhere near the Arctic Circle. A sign among the used machines says "Eagle Sports Shop." Richert has lures, flashlights, tents,

boots—a little L. L. Bean going on inside the cabin. In their regard for his goods, the river people call him Taiwan.

Close by me the other way are the yard and cabin of Louise and Sarge Waller. The remarkable propinquity of these dwellings is characteristic of nearly all settlements, large and small, in Alaska. In three hundred and seventy-five million acres—a sixth of the whole United States—so little property is available for purchase that conditions are as crowded as they are in Yonkers. A window of my cabin frames a postcard view of Sarge's yard, which, in no discernible geometric arrangement, contains boxes, tarps, stove parts, cans, buckets, Swede saws, washtubs, tires, sawhorses, fourteen fifty-five-gallon drums, and five snow machines in different states of dismantlement. When you drive along an old back road in the Lower Forty-eight and come upon a yard full of manufactured debris, where auto engines hang from oak limbs over dark tarry spots on the ground and fuel drums lean up against iron bathtubs near vine-covered glassless automobiles that are rusting down into the soil, you have come upon a fragment of Alaska. The people inside are Alaskans who have not yet left for the north. An architect I know, who prefers to style himself an "environmental psychologist," once remarked to me, "Aesthetics are not compatible with survival." In any case, Sarge Waller's place is by no means atypical of the world he has taken for his own. . . .

Rainbow over the Yukon River, Eagle.

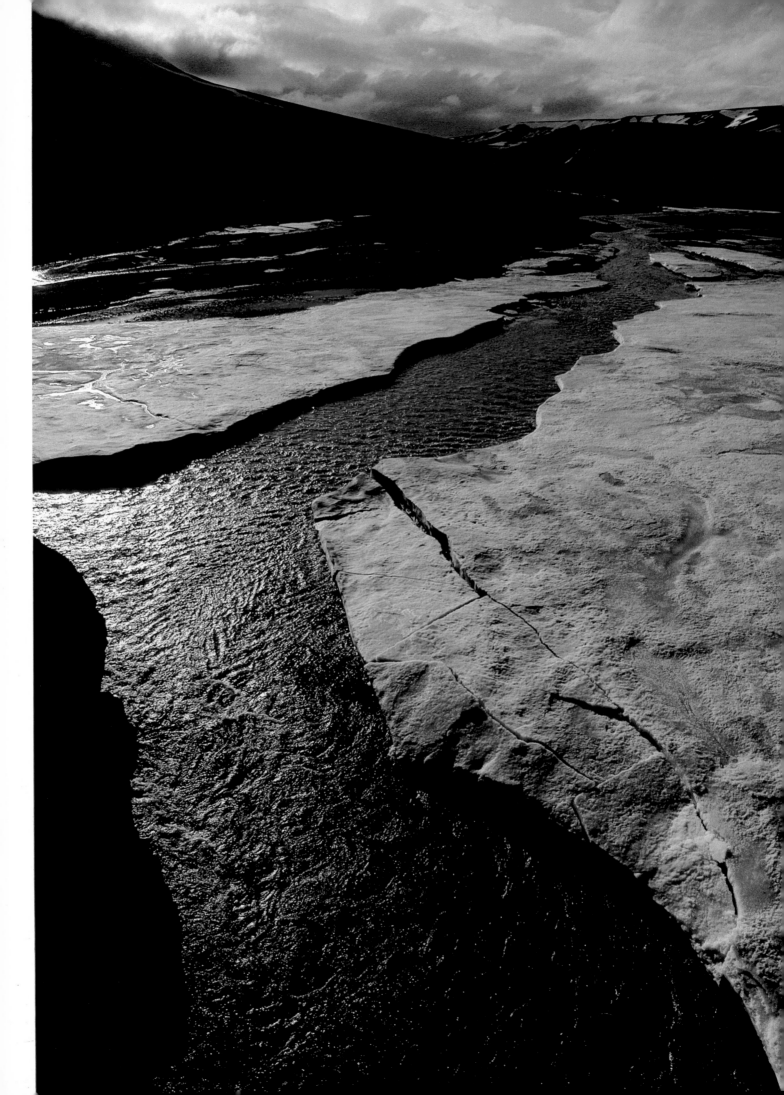

ONE SUNDAY AFTERNOON, the silent river began to move. Bank to bank fifteen hundred feet, the ice subdivided itself without particular spectacle, and, like an ore in motion on a giant belt, departed for the Bering Sea. The Yukon is a practical thoroughfare in summer and in winter, but during its times of transition it becomes almost unapproachably inimical. Great floes coming on from upriver roll, heave, compile; sound and surface like whales. Many hundreds of millions of tons of ice, riding a water discharge of two hundred thousand cubic feet per second, go by Eagle at a speed approaching ten miles an hour. Looking at the river, you cannot help but recoil. In water that cold, a human being couldn't live much more than a few minutes—a benevolent brevity, the struggle being hopeless anyway against the current and the ice. The river's edges are lined with ice that is stationary—"shelf ice," "shore ice," the first to freeze at the start of winter and the last to go in spring. It is four feet thick, but will break apart under a stamping foot, shattering into columnar palisades, untapered icicles known as "needle ice" or "candle ice." The shore ice rests on rock and gravel, while only a step or two away is the riverborne ice, big masses pounding into one another with a sound like faraway thunder, or, often, like faraway surf. These are muted sounds. For all its weight and speed, the ice moves softly much of the time, fizzing like ginger ale.

The ice run will thin out now and again, nearly disappear. The river becomes clear of all but isolated floes. In another hour, or day, heavy ice is running again—wall to wall, crunching, jamming, lethal as ever. The ice comes segmentally from upriver and from the tributary rivers. The Yukon, even above Eagle, has tributaries four hundred miles long. When ice of the Yukon, ice of the tributaries comes free and begins to run, it does so in big units. People watch for ice from Dawson— which is about a hundred miles away, in Yukon Territory—and whenever barrels, garbage, foul

debris go hurtling by on soiled floes, someone will grunt knowledgeably and say, "Dawson ice." The White, the Klondike, the Stewart, the Pelly, the Nordenskiöld, the Teslin, the Fortymile let go their ice arrhythmically and give it into the Yukon. Pelly ice. Stewart ice. Teslin ice. Fortymile ice. It takes two or three weeks for it all to go by a single point like Eagle. In weeks thereafter, it forms a temporary, bobbing delta spread miles out to sea.

With the ice comes wood. The breakup flushes out of Alaskan and Canadian uplands many millions of cords of forest debris. Trunks go by that are sixty and seventy feet long. Some ride just beneath the surface. They are called sleepers. The big logs rarely retain their branches, but many still have their root structures, and those that do are sometimes called preachers, because the roots ride down in the water while the upper trunk breaks through the surface at an angle, and bows and rises, bows and rises, as it glides by. Once in a while a big trunk will nosedive and stick like a javelin into the bed of the river. Then a following ice floe snaps it in half with the sound of a battleship gun. Sometimes the wood in the river seems as voluminous as the ice. The people of Eagle collect logs that have paused in eddies or have otherwise come near enough to shore. Firewood is worth sixty dollars a cord, and twice that in winter. People have to travel considerable distances—to forest burn areas, for example—to get it legally. So it is not just wood but a great deal of cash that is bobbing by on the Yukon. For the most part, the people can't do much, however, but wistfully watch it go. The big river delivers the wood to the Yupik Eskimos of the western coast, where there is no timber to speak of and where for ten millennia—before missionaries, books, schools, and visual aids—fires were made with fuel from a forest-mountain landscape that the Eskimos had never seen and could scarcely have imagined.

61

Spring breakup on the Toklat River.

soft, too–fluid and melodic, like nearly all the voices in the Village. The contrast with my own is embarrassing. No matter how I try to modulate it, to experiment with his example, my voice in dialogue with Michael's sounds to me strident, edgy, and harsh. He is twenty-five years old. His body is light, his face narrow, his nose aquiline. His hair, black and shining, passes through a ring behind his head and plumes between his shoulder blades. He wears a khaki jacket, patched pink denim trousers, leather boots, a belt-sheathed jackknife. He may be an Indian, but he looks like a Turk. On his head is a fur hat that has a shape of an inverted flowerpot–a long-haired fez. His thin, Byzantine mustache droops at the wing tips. He has a miniature beard, scarcely a quarter inch long, tufting from the point of his chin. His brother, Minicup, teen-age, wears bluejeans, a red headband. Minicup is taciturn but obviously interested and even inquisitive, his eyes moving back and forth between Michael and me. He was baptized Edward David. Minicup is a name he gave to himself years ago.

We are finishing dinner, a common enterprise. It began, after making camp, with a mutual presentation of what each of us had to offer. Michael and Minicup set out Spam, Crisco, Sanka, fresh carrots, onions, and potatoes. I set out tins of beef stew, and corn, tea, sugar, raisins, nuts, chocolate, and cheese. Michael, opening the Spam, said, "I remember when it cost a dollar." Between us there has been a certain feeling out of ways and means. It is my wish to follow Michael's lead, to see how he will go about things in the woods. To some extent, he seems to want to do the same with me. It was he who chose this campsite–a couple of hundred yards into the forest and away from the Yukon's right bank, on flat ground covered with deep sphagnum, close to the edge of a small, clear stream. Wicked thorns grow out of the moss on long roselike stems. We hacked at them with our knives until we had cleared an area big enough for my small nylon A-frame and the brothers' wall tent–an orange Canadian affair that Michael, for

privacy, often stays in at the Village. Before building the fire, he turfed out the moss, cutting eight inches down and removing a five-foot square. Even so, he did not get to the bottom of the moss. I then, automatically, without pausing to think, went off to the river for rocks. I brought back two or three in my arms, like loaves of bread, and dropped them on the moss. I returned to the river. The brothers followed. We all collected rocks and carried them back into the woods– gathering, in several trips, more than enough for a fireplace. I was about to begin building one but checked myself and relinquished the initiative. Why should I build the sort of three-walled fireplace I would make in Maine? I wanted to see what they would do. I fiddled with my pack and left the rocks alone. Michael and Minicup laid them out singly–one after another, scarcely touching–in the closest thing possible to a perfect circle. I could not see what the purpose of such a circle might be. It could not shield the fire from wind, nor could it support the utensils of cooking. Possibly it was to retain the spread of smolderings through the moss, but it seemed awfully large for that. Why had they made it, unless purely as an atavistic symbol, emplaced by what had by now become instinct?

Now Michael, finishing his dinner, has a question for me. He says, "Why did you go get the rocks?"

I mention fireplaces I have made on lakes and rivers in Maine.

"Maine?" he says. The word "Maine" seems to excite him. "Have you been to L. L. Bean? I sometimes send for shirts and pants from there, and boots similar to yours."

Through the late but barely graying evening, we walk a couple of hours beside the Yukon, going upstream at first, within sight of the shaved incongruous border, which, on the far side of the river, comes up from the south and plunges down a ridge to the water. For the most part, we walk by the river, but we make occasional penetrations through alder hells and into the woods to assess

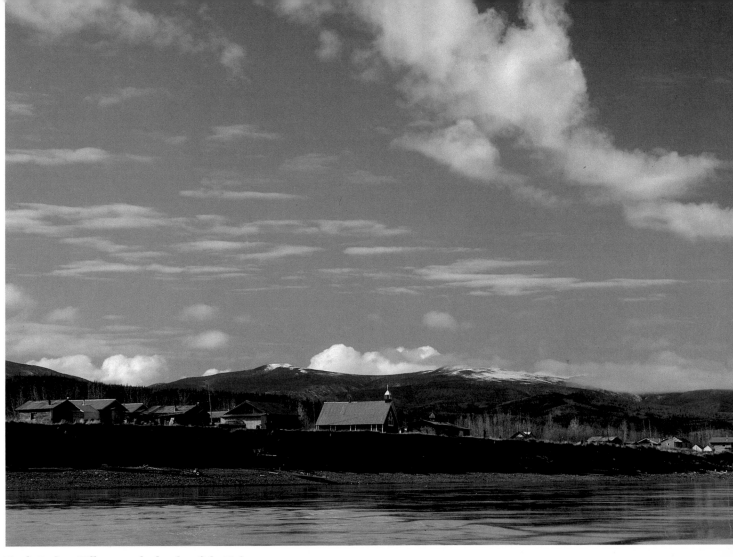

Eagle Indian Village on the banks of the Yukon.

the trees. In many places we see upheavals where bears have dug roots. The ground appears to have been plowed. Bear tracks, heading upriver and down, are in sand at the edge of the water. Michael tells of a couple of tourists who were approaching Eagle not long ago when they saw a grizzly chasing a black bear. The grizzly caught the black bear, tossed it around, broke its neck, and started to eat the warm carcass. The people got out of their car with cameras and moved toward the feast. The grizzly charged them. They were lucky. They made it back to their car.

Resting on Michael's shoulder is his .30–'06. After a time, we turn around, retrace our tracks, and then go on for some miles downriver. We pass the high stump of a white birch, eight inches in diameter. Inside is nothing. The wood, over many years, has completely disintegrated and disap-

peared. The bark–firm, unaltered, and solid– stands like a stovepipe on its own. Michael stops, and lifts his rifle as if he is about to fire. He moves it slowly, pointing along a bend of the river. He does not intend to shoot. He is using the rifle's six-power scope as if it were a monocular. He often raises the gun just to look around, to look at anything at all–the better to examine it, through the scope. This is more than a little disconcerting when he happens to be looking at you. Lowering the gun, he says, "Is 'Robinson Crusoe' fiction?"

I tell him it is, and ask why he wants to know.

He shrugs, and says he has always wondered. A scattering of feathers attracts his eye. He picks one up, saying, "A hawk killed a robin." He says he once climbed Eagle Bluff for a peregrine chick, trained it, and later let it go. We come upon a set of amoeboid tracks ("Porcupine") and grapelike

clusters with star points in the sand ("Fox"). That brown object in the brush – what is that? "A garbage bag from Dawson."

I ask Michael where he earned the money for his 1967 Oldsmobile Vista-Cruiser.

"The Slope," he says. As an apprentice heavy-equipment operator, he has two thousand hours to his credit. Operating a bulldozer, he helped build the haul road that accompanies the Trans-Alaska Pipeline.

"Thanks to you, people will drive from the Caribbean Sea to the Arctic Ocean," I remark.

"Caribbean Sea?" he says. "Where is that? Is it far from New York?"

"It would be like going from here to Adak."

"Pretty far," he says, and after a moment mentions that one of his boyhood friends in Eagle Indian Village was sent off to be raised in New York. The boy's mother and father and his Uncle Pete mixed grape juice with wood alcohol from the school duplicating machine and drank it. The father went blind. Uncle Pete and the mother died. "The kids were not fed three times daily after that. Their home was upside down." It was arranged, somehow, for one boy to go off and live with a family in New York. "When he came back, years later, he knew nothing," Michael says. "He knew white things but not Indian things. He punched holes in foil in which meat was roasting. The same with potatoes. He saw a porcupine and thought it was a raccoon. He knew nothing." Michael walks in silence for a while, and then, as if trying the words on his tongue, he repeats, "Caribbean Sea."

Beside us now is a slough. It separates the Yukon's right bank from what Michael calls Old Man Clark's Island. "We have rabbit drives there. Drive the rabbits from one end of the island to the

Alaskan brown bears arbitrate a controversy over fishing rights.

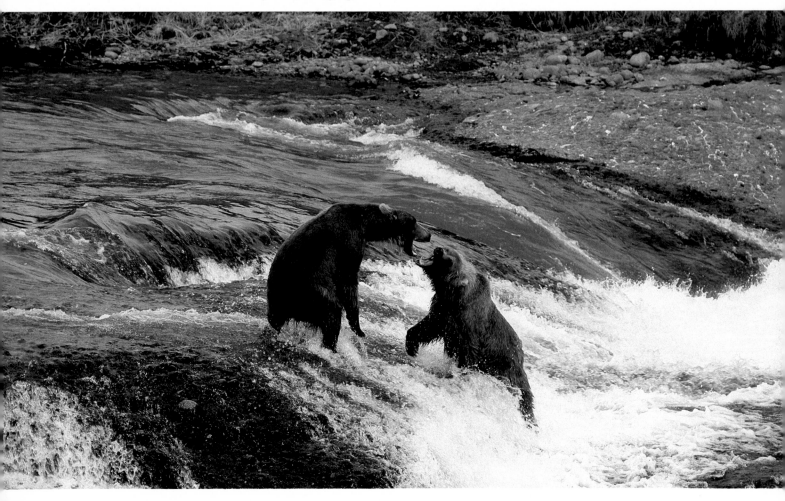

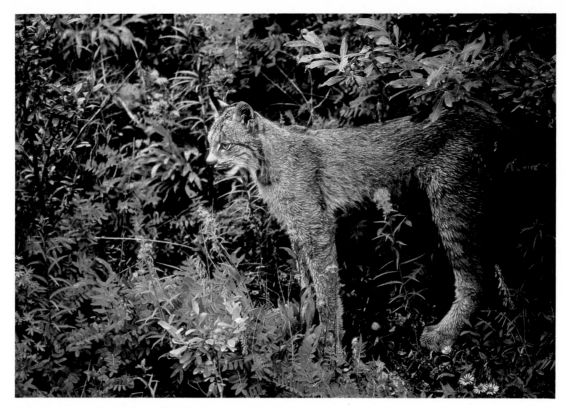

A lynx, normally nocturnal, makes a rare daylight appearance to stalk a snowshoe hare through a bed of flowers.

Murres nesting above the Bering Sea.

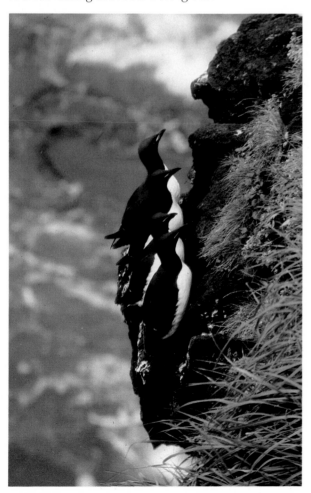

other and kill them. Not now, though. They go through a cycle. Now there are no rabbits." He has on occasion come to this side of the river to hunt sheep. "When you can barely see a sheep," he says, "the sheep can count your fingers. That's how sharp eyes they got." We see a cottonwood that has been chewed by a beaver. We see, moments later, the beaver. Michael raises his rifle and follows it through the scope. Head up, swimming, it cuts a straight wake in the almost still water of the slough. Michael chooses not to shoot but to save the beaver. He will shoot it in time. He looks up from the gun. "This place compared to a city is—well, pretty nice," he says. "We have a little bit of everything—animals, fish, mountains, forest. Even people down the river envy what there is in this country." With a slap on the water, the beaver is gone. A light, cold rain begins to fall. We return upriver to the campsite and the tents.

67

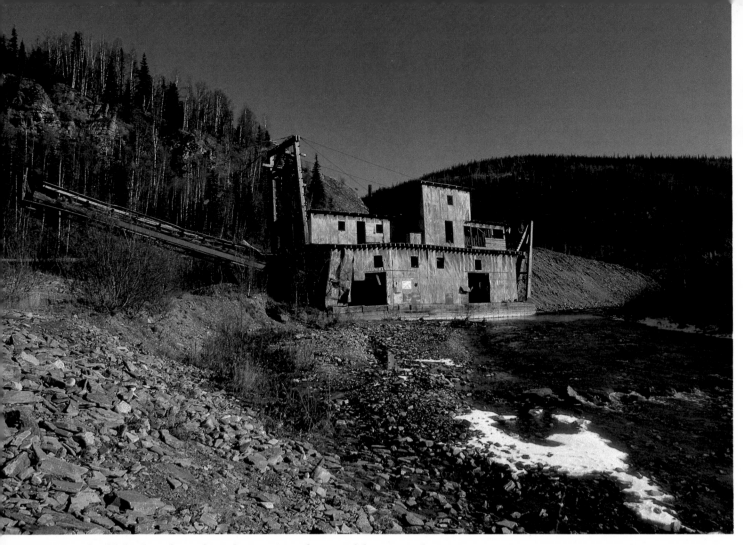

Abandoned gold dredge, the Jack Wade #1, on a tributary of the Fortymile River.

WYMAN FRITSCH, a conventional placer miner, has a nugget larger than his thumb. He found it in the Discovery Fork of American Creek, some ten miles out of Eagle, and he says it is by no means the largest one he has taken from that stream. He has been mining there for fifty years. He was a boy when he came into the country. He is currently known as The Man with the Big Nugget. He showed it to me the other day, so that I could hold it in my hand and rub the genius of the gold. It was lumpy, pitted, pocked, rough, ugly—an apparent filling from the tooth of a Sasquatch. The marvel of it—as the earth's elements go—is that when Fritsch came to it with his mining equipment, scraping up the deep gravels of American Creek, it was there as nearly pure

metal. Gold is not merely rare. It can be said to love itself. In the idiom of science, it is, with platinum, the noblest of the noble metals—those which resist combination with other elements. It wants to be free. In cool crust rock, it generally is free. At very high temperatures, however, it will go into compounds; and the gold that is among the magmatic fluids of interior earth may be combined, for example, with chlorine. Gold chloride is "modestly" soluble, and will dissolve in water that comes down and circulates in the magma. The water picks up many other elements, too: potassium, sodium, silicon. Heated, the solution rises into fissures in hard crust rock, where the cooling gold breaks away from the chlorine and—in sizes ranging from specks to the eggs of

68

geese—falls out of the water as metal. Silicon precipitates, too, filling up the fissures and enveloping the gold with veins of silicon dioxide, which is quartz.

Gold can be taken from such veins with dynamite blasts, pneumatic drills. But that requires the funds and efforts of a large corporation. The deepest mine in the Western Hemisphere—the Homestake gold mine, in Lead, South Dakota—goes down into the earth more than a mile and a half. Its capital cost to date has been upward of a billion dollars. Alaskan lone miners—people who have, or who have had, names like Pete the Pig, Pistolgrip Jim, Groundsluice Bill, Coolgardie Smith, Codfish Tom, Doc La Booze, the Evaporated Kid, Fisty McDonald, John the Baptist, Cheeseham Sam, The Man with the Big Nugget—prefer to wait for God to break open the rock, to lift up and expose something like the Sierra Nevada and with epochal weathers blast it and spall it and tear it apart until the gold rolls out into the rubble of the streams. Placer mining—separating gold from stream gravels—is difficult work, but beside any other method it is comparatively easy. *"Placer,"* in Spanish, means "pleasure."

This is the country that Arthur Harper came into in 1873. The journey itself—two thousand miles, a large part of it on scarcely charted Arctic rivers—was an accomplishment in exploration, but to Harper that was incidental. A native of Ireland—intelligent, intense—he was a big bull-shouldered man with an H-beam jaw and a look so glazed it correctly suggested a quest. He had spent a lot of time in American goldfields, and he had what the geologist Alfred Hulse Brooks later described as "a conception of the broader orographic features of the western cordillera." That is to say, Harper had noticed that the important gold discoveries of North America had occured in the Western mountains, and that the mountains went a great deal farther north than did—at that time—the discoveries. This suggested to him that as the highlands traced their way around the basin of the Yukon River, in Canada and in Alaska, their con-

tributive streams in all likelihood contained undiscovered deposits of gold. Always confident that this was true, he searched with only modest results for upward of twenty years. Elusive stories were already in the air. An itinerant missionary named Robert McDonald, eleven years ahead of Harper, was said to have found a stream in the country where gold was so concentrated he picked it up with a spoon. There was no saying where, except that it was probably a tributary of Birch Creek. The strike in 1880 at what became Juneau was far to the south but was nonetheless encouraging. It was the northernmost discovery in North America to date. Harper tried Birch Creek, the Fortymile, the White, the Stewart,

A miner shows off five ounces of placer gold in his pan.

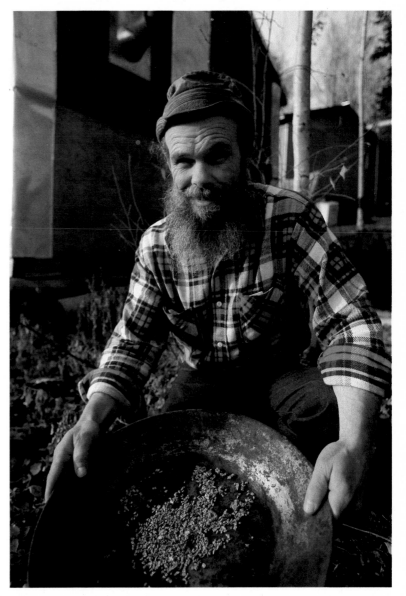

the Tanana, and myriad branching streams. He went to some of the right rivers and looked in all the wrong places. The luck of the Irish he had left at home. He killed and ate game along streams near the mouth of the Tron-diuck, missing the gold below. Here and there, with his pan, he did find enough color to support his conviction. With Leroy Napoleon (Jack) McQuesten, who came into the country by the same route in the same year, he sent back the word that drew prospectors northward in numbers sufficient to favor a find. And so—in a broad orographic way—he was the discoverer of the gold of the Yukon.

McQuesten, from Maine, was no less a believer than Harper, but it was McQuesten's way to support the search rather than pursue it. He took furs downriver and returned with goods. Representing the Alaska Commercial Company, he set up trading posts—for example, Fort Reliance (1874), forty miles up the Yukon from what came to be known as the Fortymile River. The posts were served by stern-wheeled steamers arriving from the Bering Sea. McQuesten grubstaked prospectors—in many cases, for penniless year after penniless year—with a generosity that would have bordered on charity were it not for his merchant's instinct that when the dust at last came out of the streams it would settle in the merchant's safe. The first major strike in the region was made on the Fortymile in 1886, when prospectors named Harry Madison and Howard Franklin—acting on suggestions made by Harper—went twenty-five miles up the river, dug to bedrock, and found coarse gold. Just before freeze-up, they emerged with the news. After volunteering to relay it to the outside world, an Alaska Commercial Company river pilot named George Williams made an overland trip and raced the coming winter. He almost survived the trip. Of exhaustion and cold, he died like Pheidippides delivering his message. McQuesten, who was in San Francisco buying supplies, bought more supplies. He need hardly bother to help spread the word. Along the two thousand miles of the

Yukon, a dozen whites had lived before. They would now be coming in many hundreds, and soon in many thousands. Harper and McQuesten had spent thirteen years preparing the way—developing transportation, gathering detailed geographical and geological information. Needless to say, they readily established a trading center where the Fortymile goes into the Yukon. Shovels and flour, picks and pans were for sale there. Advice was plentiful and free.

For seven years, the Fortymile—yielding as much as eight hundred thousand dollars in a season—was the focus of attraction in the mining of Yukon gold. The drainage was almost wholly in Alaska but ran a few miles into Canada—dissecting a high plateau immediately to the south of what is now Eagle. In 1893, excitement shifted to a relatively distant part of the country. McQuesten grubstaked two prospectors named Pitka and Syroska, sending them downriver and into the hills to have another look for the Reverend Mr. McDonald's legendary spoonfuls of gold. Pitka and Syroska made their strike at a fork of small streams some fifty miles from the Yukon, in a world of mica schists and quartz intrusions, of sharp-peaked ridges, dendritic drainages, steep-walled valleys, flat spurs, and high, isolated mountains locally known as domes. While find followed find, small brooks acquired their ultimately storied names—Mammoth Creek, Mastodon Creek—and since all of them drained into Birch Creek, the area became known as the Birch Creek mining district. Hundreds of miners left the Fortymile to rush to the new discoveries. McQuesten, of course, followed, and built a store. Because miners were so scattered in the hills, McQuesten established his trading post at the river port that supplied them, which had been named Circle City in the mistaken belief that it was on—and not, as it was in fact, fifty miles below—the Arctic Circle. Quickly becoming the foremost settlement on the Yukon, it proclaimed itself "the largest log-cabin city in the world." By 1896, there were ten thousand miners in the dis-

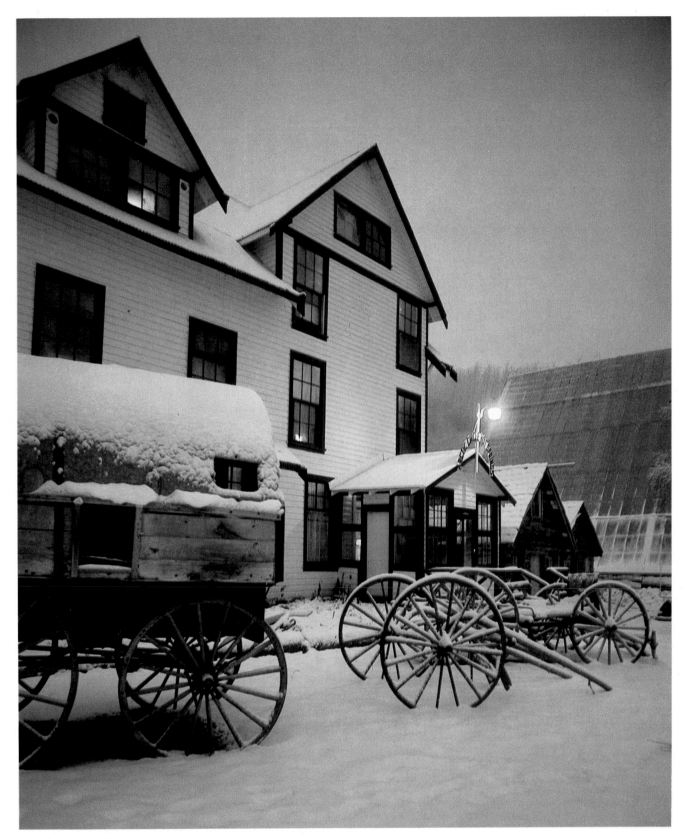

Hotel at Circle Hot Springs.

trict. The resident population of Circle was twelve hundred. Works of Shakespeare were produced in its opera house. It had a several-thousand-volume library, a clinic, a school, churches, music and dance halls, and so many whorehouses they may have outnumbered the saloons. Then certain fresh information came floating down the river from the half-abandoned settlement at the mouth of the Fortymile.

Two men known for their low credibility had walked into Big Bill McPhee's Caribou Saloon, at Fortymile, and announced a new find upriver. Scarcely an eyelid moved. One of the men, Tagish Charlie, was an Indian. The other was Lying George Carmack. Lying George said they had found pay on a small stream off the Tron-diuck,

Recent placer activity in the Fortymile country.

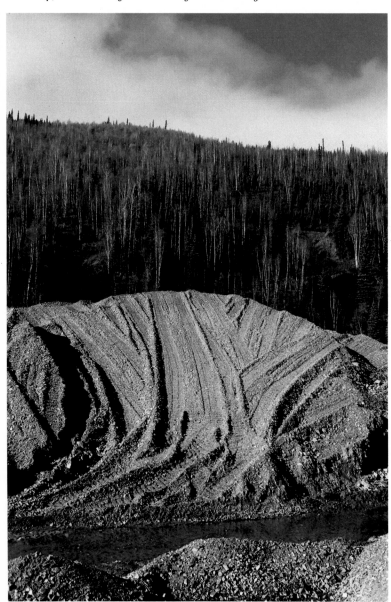

where a third member of their party, an Indian named Skookum Jim, had remained to guard their claims. The saloon was full of miners. No one was much impressed. For every worthwhile tip that might ever come along there were dozens upon dozens of meretricious leads to feverish diggings and dismal disappointment. Moreover, Carmack had a reputation for tall tales and short accomplishments. He was also the victim of their prejudice, for he was the white husband of a Tagish squaw. He had gone so native he actually wished to be chief. He encouraged himself with a double dram of whiskey. It mattered a great deal to Carmack that these skeptics believe him. He felt, he said later, as if he had dealt himself "a royal flush in the game of life." He and his companions had staked all the ground the law allowed them, and now he earnestly sought the respect that might come to him if he made these beggars rich. He finished his whiskey, and he took a used rifle cartridge from his pocket and turned it upside down. Gold is characteristic of the stream it comes from—the shape of the nugget, the rustlike shadings of the flake. Flat, rough, oblong, tear-shaped, round, smooth—bits of gold are the consistent signatures of the source placer. An experienced miner can look at a nugget and name the stream. A crowd drew in around Carmack's gold. Only a small amount was there, but no miner in the saloon had seen its like before. They fell silent. The surveyor William Ogilvie, who was working out of Fortymile at the time, made the quiet observation that, in effect, the gold could not have fallen from the sky. Faking nonchalance, miners melted away. The claims of George Washington Carmack, Skookum Jim, and Tagish Charlie were recorded, and soon the stream where they had staked them was named Bonanza Creek. It is the richest placer stream that has ever been found in the world. The discovery claim was ten miles above the Tron-diuck—an Athapaskan phrase meaning "hammer water." (Fish traps made of stakes had been driven into its bed.) Tron-diuck, alchemized into English, became Klondike.

I cannot resist a digression into the fate of Big Bill McPhee, who was apparently generous with his cache in a way that any number of his clansmen are not. One person who asked for his help after Carmack's visit to the saloon was Clarence Berry, a young man from California who was eager to stake his own claims and who had all the determination and physical strength required in a miner but had come to Fortymile with no money, no food, no supplies of any kind. McPhee told Berry to go out to the cache and take whatever he needed. Berry's claims, as things proved out, were among the richest on Bonanza Creek, and they led to the development of a widespread mining conglomerate and, later, to added fortunes in California oil. Big Bill, for his part, settled in Fairbanks. One day his home and saloon there burned to the ground, destroying all of his assets in the world. Berry, in California, heard of this through his company and at once sent a message north: Rebuild, restock, restore everything; have all accounts sent to me.

The fact that a hundred and fifty million dollars was awash in the drainages of the Klondike diminished but did not extinguish the goldfields of the Alaskan Yukon. Circle City declined by eighty per cent but did not ghost out. Enough miners remained in the Birch Creek district to remove half a million dollars' worth of gold in the season after the Klondike strike. The Fortymile region was drained of talent, but not necessarily of the best talent. Established miners continued to work its streams. For the majority, certainly, the years around the turn of the century were ones of rushing to and fro, impelled by the brightness of news. Miners of the Alaskan gold country went into the Klondike with the advantages of propinquity and experience over the green multitudes coming up from the United States, most of whom found every stream that showed any color completely staked. The Klondike was in Canada. Ninety per cent of the miners were American. The Crown imposed a heavy tax on wealth drawn from Her Majesty's placers. The Royal Canadian Mounted Police, understaffed and apprehensive, sent a letter to Ottawa setting forth the possibility that the Americans might by force attempt to move the international boundary far enough east to comprehend the Klondike. But, without violence, many of them just went quietly "home," crossing the line to Alaska, to settle in places—and to work streams—that often flaunted remarkably patriotic names: Eagle, Star City, Nation, American Creek, Washington Creek, Fourth of July Creek. In 1900 came the rush to the beaches of Nome. Eight thousand left Dawson, the instant city where the Klondike meets the Yukon, and conspicuous among them all was Ed Jesson, who came walking into Eagle carrying a bicycle. Riding down the frozen river, he had thirteen hundred more miles to go, but for the time being he was going nowhere; his bearings were cold and stiff. When the temperature went up enough, he rode away. Meanwhile, someone else on his way to Nome went by on ice skates. Populations halved in Eagle and Circle, but, as before, miners by no means disappeared from the country. Nor have they ever. Birch Creek and the Fortymile, where the Yukon mining began, have always since discovery had miners on their creeks.

The principal technique of placer mining is to wash gravel through a long, narrow sluice box, its bottom ribbed with partitions that simulate the riffles of a stream. Gold and heavy sands settle among the riffles, while stones and boulders move on through the box and out the far end as "tailings." The pioneers, with their picks and shovels, could move about five cubic yards of gravel a day. Before long, these individual prospector-miners were outdone by small groups who could collectively move more stone—for example, with mechanical scrapers—and who could greatly increase available water by building elaborate wooden flumes. Giant, high-pressure hoses were developed as well, with dug reservoirs feeding mountainside ditches from which water would fall through pipe to emerge from nozzles with power enough to excavate gravels to bedrock. Inevita-

bly, big dredges were built, too – by companies that bought up claims and worked entire streams. The dredges floated on ponds of their own making and on capital from cities months away.

Notwithstanding all this, the individual miner persevered. Quite apart from the major strikes, a kind of life had been discovered that to some – to Axel Johnson, for example – was no less alluring than the gold. Johnson was a Swedish fisherman who came into the country in 1898 and built a cabin, dug a garden at the falls of the Seventymile River. He worked Big Granite Creek, Alder Creek. He "sniped" a lot of his gold – just took it from likely spots without settling down to the formalities of a claim. He would go to the deep holes of stream rapids and periodically clean them out with a large instrument that resembled a spoon. Or he might take, say, eighteen hundred dollars out of a little bench of gravel, working it by hand. When he came into Eagle for mail and supplies, he sniped as he travelled, and once picked up sixty-seven ounces on the way. He trapped; and below his falls he caught Arctic grayling in such quantities that he had enough to dry and keep for winter. He lived well. He died in his cabin, in 1933. The life that attracted him, with its great liabilities and its great possibilities, has gone right on attracting others, and has been enhanced occasionally by a fresh sense of boom. There have, in fact, been three boom eras in the gold streams of Alaska. The second came in the nineteen-thirties, when the price of gold doubled. During the rushes of the eighteen-nineties, the price had been about seventeen dollars an ounce – a figure that remained essentially steady until 1934, when the government raised it to thirty-five. Lonely miners out on the creeks were suddenly less lonely. Fresh activity was encouraged as well by the almost simultaneous advent of the bulldozer, which could push around roughly four hundred times as much gravel per day as an old-timer with a pick and a shovel. The third Alaskan gold boom began in the early nineteen-seventies, when the United States allowed the price to float with the world market and announced that American citizens, for the first time in forty years, would be allowed to buy gold and save it. The price giddied. It approached two hundred dollars an ounce. Then it settled back to present levels – around a hundred and fifty.

New miners come into the country every year – from Nevada, Montana, Oregon, wherever. They look around, and hear stories. They hear how Singin' Sam, on Harrison Creek, "hit an enrichment and took out nuggets you wouldn't believe." They hear about "wedge-shaped three-quarter-inch nuggets just lying there where water drips on bedrock." They hear about a miner in the Birch Creek district pulling nuggets from the side of a hill.

"I have always been mining, always preparing ground. I'm not telling you how much money I've got ready to dig up. She's in the bank. Trouble is, there's too much gravel with it."

In tailing piles left behind by dredges, people hunt for nuggets that were *too big* to get stopped in the sluice boxes and went on through the dredge with the boulders. People reach into their shirt pockets and show you phials that are full of material resembling ground chicken feed and are heavier than paperweights. Man says he saw a nugget big as a cruller tumbling end over end in the blast from a giant hose. It sank from view. He's been looking for it since. Man on Sourdough Creek, working for someone else, confessed he had seen a nugget, and reached to pick it up, and found it was connected by a strand of wire gold to something much larger and deeper. He broke off the nugget and reported nothing. He could hardly mark the spot. Later, he went back to try to find what was there – he knew not where.

74

Frost softens the contours of a forest near Eagle.

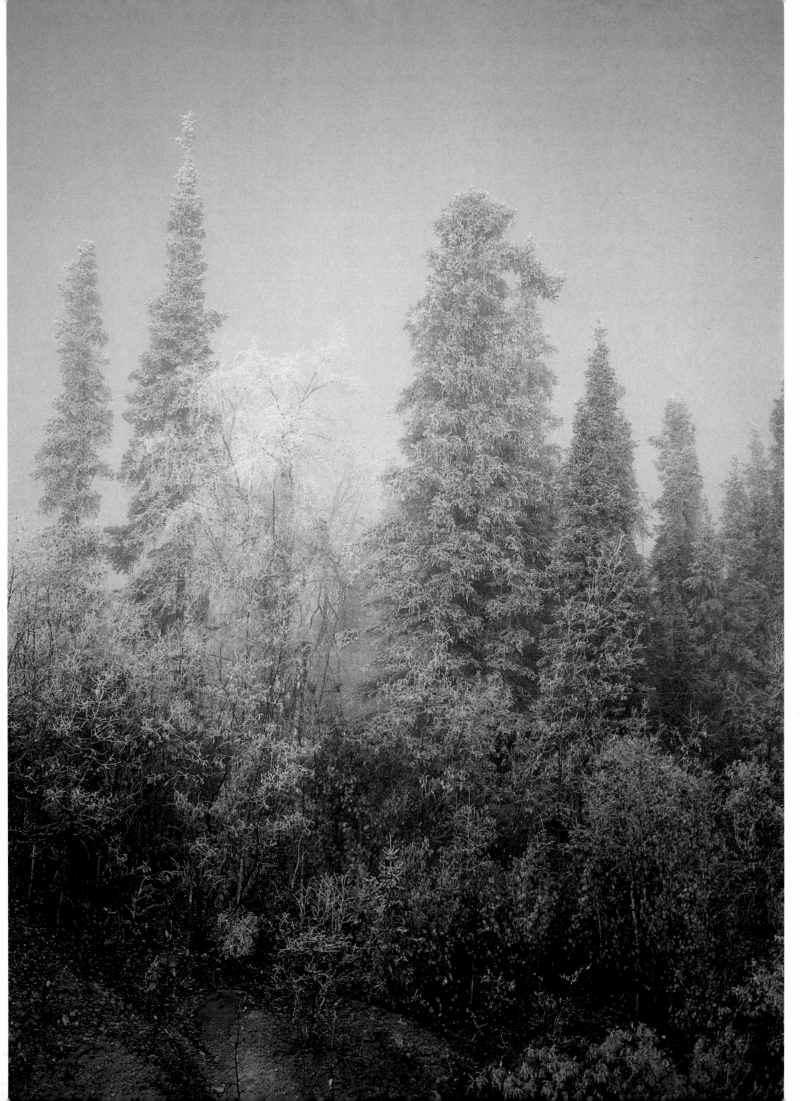

Old Episcopal Church by the Yukon, Eagle.

W HEN MINERS and prospectors, in the eighteen-nineties, had begun appearing in the country in rush quantities, there was–on the American side of the boundary–little order and less law. The War Department, imagining a need for both, sent Captain P. H. Ray on a journey of reconnaissance in 1897. Ray travelled up the Yukon on a cargo-carrying riverboat that was hijacked when it reached Circle City. The miners took the supplies, because they were otherwise going to starve, and they scrupulously paid a price they thought fair. (The boat had been saving its goods for Dawson, in Canada, which glittered with economic inflation.) Ray continued upriver. When he wrote his report, he said there were eighteen thousand people in the region, "which on our side of the boundary is without semblance of law, civil or military." There was a need for Army installations, he said. "A turbulent element is coming into the country that will have to be controlled." He recommended, among other

things, a military garrison at the mouth of Mission Creek. It was a good site–fairly level and well-wooded ground on a high bank of the Yukon–close to the international boundary. Ray had scarcely left the country when twenty-eight miners platted a townsite on the same bend of the river where he had said the fort should be. If they were not the first real-estate speculators in the Territory of Alaska, they were somewhere high on the list. They might have called the place, say, Rustic Wilderness, but they happened to glance up at the white-headed birds that lived on the river bluff that would dominate the town, and decided to name it for them.

For a hero dead in the Philippines, the Army base was called Fort Egbert. Police work became the least of its preoccupations. The Army Signal Corps wanted to extend its great web to cover all America, including the upper Yukon. Communications in Eagle were nothing to write home about. After the Eagle post office was established,

76

in 1899, the Post Office Department, in Washington, decided to establish a winter mail route across the Alaska Range from Valdez, on Prince William Sound, to Eagle, on the Yukon. A carrier, with eleven horses and a sack of mail, set out in October for the north. Eleven horses died. The carrier kept going, of course, and in the dead of winter he finally came walking into Eagle. The trip had cost the government three thousand dollars. In the sack were three letters. The Signal Corps meant to improve on that with instantaneous messages, by overland wire, from Eagle to all the world. Laying the wire was a project weirdly analogous to the building of the Trans-Alaska Pipeline, in that it required the clearing of a tortuous route north from Valdez (now the pipeline's southern terminus), with camps set up along the way and crews working the equivalents of overtime and double time. The crews were soldiers, earning thirteen dollars a month. Their boss was Lieutenant William Mitchell, twenty-one years old. He was on his way to fame in the air, to a court-martial, to a vindicating posthumous medal, but this was two years before Kitty Hawk, and all he had on his mind was how to move men and materials through several hundred wilderness miles where men and mules carrying heavy loads sank deep into muskeg. Mitchell's solution was to transport in winter what he would build in summer – a procedure new to the Army, and requiring Mitchell to become an expert in everything from Arctic clothing to the efficacy of sled runners. To protect morale, he prohibited thermometers. Work proceeded even at forty and fifty below. Mitchell was not lacking in flair. He was a Crockett on snowshoes, a beardless Boone. Travelling the line from crew to crew, he wore fringed hide clothing trimmed with extensive beadwork. His rifle was kept in a beaded sheath. He devised a parka of stuffed mattress ticking. He wore a beaver hat.

Poles were set, and wire strung, in summer. Repair cabins were built at regular intervals, relay stations where necessary. Finally, in June of 1903,

the project was complete. Mitchell before long departed. His construction was fated for brief use and long desuetude. Isolated bits of wire still hum in the wind. Cabins here and there remain intact. For the time being, though, in 1903, a town that would celebrate its nation's Bicentennial beyond the reach of television and telephone – without public utilities of any kind – had a telegraph line from which word of great moment could go in an instant around the earth.

"Have Charly Harper in custody."

"Get typewriter from clerk's office and ship to this office."

"Pawn takes pawn."

"Queen to King's Bishop Four."

"Knight to King Six. Check."

"Ascertain if Alexina Byron is a proper person to conduct a barroom. The Judge is adverse to granting liquor licenses to women."

The date of that last message was the eighth of August, 1905 – a wet summer in much of the country, very good for mining but with less rainfall locally and, in the Fortymile, consequent despair. In the desk of John Robinson – Deputy United States Marshal, Eagle, Alaska – was a letter from an agent of the White Pass & Yukon riverboat company in Dawson, Yukon Territory, that said, "Dear Sir: I have your letter of May 31 advising me of four insane persons coming up on the Lavelle Young en route to the outside. I may say that we have no regular place for the accommodation of insane people; however, we have often taken out batches of insane people for the

Soldier's quarters in the restored Fort Egbert, Eagle.

The Wickersham Courthouse in Eagle, built by a U.S. District Judge of the same name who in 1903 made the first attempt to climb Mount McKinley.

Northwest Mounted Police here, and if they are violent or apt to annoy passengers we construct cages for them on the main deck." Robinson presumably shipped them out. After at least a dozen telegrams went up and down the country, Alexina Byron got her license to operate a barroom, although women were not to be served there. Eugene Miller was jailed that fall for indecent exposure, Frank Van Norstran for cursing and swearing and making unnecessary noise. Winter came down particularly hard. A few days after the first of December, Berber the tailor froze to death. On about the same day—at any rate, on December 5, 1905—a stranger appeared on a sled on the Yukon, came up the bank, and mushed into town. The temperature was sixty degrees below zero. He was of modest height, with a wiry spareness that was somehow evident within his abundant furs. His hair was thin and was beginning to

78

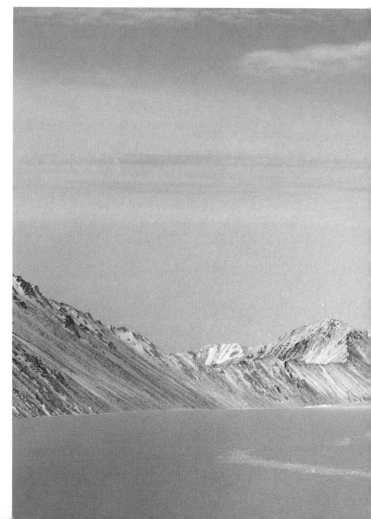

Dog team on the Muldrow Glacier, Mount McKinley National Park.

recede. His glance was level, prosaic. He asked where he could send a telegram. His voice was accented, attracting no interest, for half the Tower of Babel was already in the goldfields. In the telegraphy office, he sat and wrote for some time. The moment did not call for a ten-word cryptogram. Nothing had been heard from him for two and a half years. He wrote, actually, a thousand words. Addressing the message to Dr. Fridtjof Nansen, in Christiania, Norway, he signed it "Amundsen." The essence of what he had to say was that he had discovered the Northwest Passage.

His sloop, Gjöa, was frozen in sea ice nearly four hundred miles north. To get from the ship to Eagle, he had travelled a great deal farther than that: over passes among mountains of nine thousand feet, then following the routes of frozen rivers–the Coleen, the Porcupine, and two hundred miles on southward up the Yukon. An Eskimo man and woman travelled with him as far as Fort Yukon, and a whaling captain whose ship was so badly damaged that he was on his way to San Francisco for another. Amundsen stayed in Eagle two months, going like everyone else to the well house for his water, and waiting for mail from home. His men were provisioned and safely encamped, and for him, meanwhile, Eagle was more comfortable than the shore of the Beaufort Sea. Neither in "The North West Passage" or in "My Life as an Explorer" does he say what he thought of Eagle's collective cupboard, but he would have had his Alaska strawberries, his bacon, doughnuts, condensed milk, sweet chocolate. Butter cost as much as four dollars a canned pound, oranges about fifty cents apiece. A hundred pounds of sugar was thirty dollars, a hundred pounds of flour fifteen. The cost of a breakfast of ham, eggs, bread, butter, and coffee approached three dollars. At the Eagle Roadhouse all these years later, the cost of the same breakfast has gone up fifty cents. Alaska strawberries were dried beans.

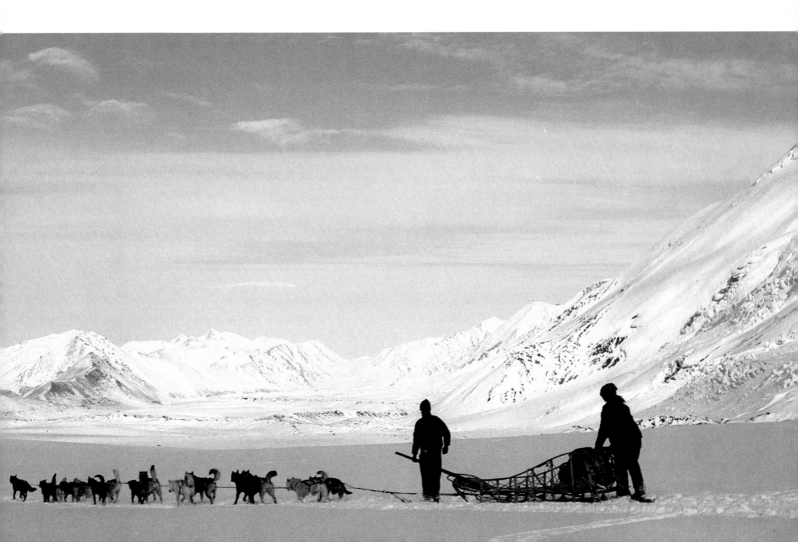

The nine officers and the hundred and thirty-eight enlisted men of Fort Egbert apparently gave him an awestruck, warm reception. His tenth day in Eagle was December 14th. It would be the date, six years later, of his unprecedented arrival, with associates and dogs, at the South Pole. Meanwhile, though, he had tales enough to tell. He had determined, on his voyage, the exact location of the North Magnetic Pole—the other, and more scientific, purpose of his trip. He had spent two winters frozen in ice. He had come near burning the Gjöa to a crisp. In August, less than four months before, he had been trying to pick his way westward through shallow water that had never been sailed, and he felt such stress that he could not eat or sleep. One sounding would be more discouraging than the last. The bottom was a lethal maze. The hull barely slid above it, once with an inch to spare. The Gjöa thus crept westward, and on the western horizon one day there was a sail. "A sail!"

It meant the end of years of hope and toil, for that vessel had come from San Francisco through Bering Strait and along the north coast of Alaska, and where its deep belly had floated, we could float, so that all doubts of our success in making the Northwest Passage were at an end. . . . Instantly, my nerve-racking strain of the last three weeks was over. And with its passing, my appetite returned. I felt ravenous. Hanging from the shrouds were carcasses of caribou. I rushed up the rigging, knife in hand. Furiously I slashed off slice after slice of the raw meat, thrusting it down my throat in chunks and ribbons, like a famished animal, until I could contain no more. Appetite demanded, but my stomach rejected, this barbarous feast. I had to "feed the fishes." But my appetite would not be denied, and again I ate my fill of raw, half-frozen meat. This time it stayed by me, and soon I was restored to a sense of calm well-being.

The sighted ship was a whaling vessel, and when the whalers met with the company of the Gjöa they guessed that Amundsen was at least fifty-nine and possibly as much as seventy-five years old. From the age of fifteen, he had had

what he described as "a strange ambition" to "endure . . . sufferings" at extreme latitudes: "Perhaps the idealism of youth, which often takes a turn toward martyrdom, found its crusade in me in the form of Arctic exploration." He was thirty-three years old.

The Arctic tree line in Alaska and Canada does not even closely follow a degree of latitude but is a jagged graph made by the digital extremities of the boreal forest as they reach with varying success into Arctic river valleys. Amundsen's route from the Gjöa to Eagle happened to go up the valley of what has since proved to be the northernmost extent of trees. As he travelled southward (for the most part on skis), he was impatient to glimpse the beginnings of the forest, for he had not seen a tree in two and a half years.

I . . . knew that on this day we should reach the wooded district, and I was very excited at every turn in our course. When at length the first fir tree stood out against the sky up on the ridge—a very diminutive, battered little Christmas tree, hanging out of a crevice—it produced a wonderful sensation, reminding me that we were now out of the Polar regions and on more homely human ground: at that moment I could have left everything that was in my charge and scrambled up the rock to catch hold of that crooked stem and draw in the scent of the fir trees and the woods.

Amundsen remembered his two months in Eagle as a "cherished" and "pleasant" time. The cabin he lived in belonged to Frank Smith, the manager of the Alaska Commercial Company store. It is still here. The main part is only twelve feet wide and fourteen deep, with two extensions out the back that make it long and narrow, like the Gjöa. Only the name of the street it is on has changed. The cabin is just off First Avenue, on Amundsen.

Amundsen had heroes, his own capacity for awe. He met such a person on his way back to his ship. He departed Eagle February 3rd (leaving Fix, one of his sled dogs, behind, because Fix had

gorged himself on the provender of Eagle and was a useless ball of fat). He retraced his route, rejoined his two Eskimo companions in Fort Yukon, and had gone maybe a hundred miles up the Porcupine when he saw one day a dark, solitary speck on the distant snow. It moved toward him. An hour later, the gap closed, and he met a man named Darrell, who was hauling a small toboggan by hand. Darrell worked for the Hudson's Bay Company, and he was carrying mail. He had come from the Arctic Ocean and had crossed the mountains alone, because an unusually heavy snowfall on the North Slope was too deep for dogs. "I could not believe my eyes," Amundsen wrote in one book. "Here was a man, hundreds of miles from the nearest human being, with not a soul to aid him in case of illness or accident, cheerfully trudging through the Arctic winter across an unblazed wilderness, and thinking nothing at all of his exploit. I was lost in admiration." And in another book he said, "I stood looking after him as he disappeared from view, and I thought, if you got together a few more men of his stamp, you could get to the moon."

An isolated, dwarfed spruce, bearing twenty sets of limbs on a mere two feet of trunk, fights for survival far beyond the present timberline.

BRAD SNOW and Lilly Allen came into the country in 1974. They were twenty-six and twenty-one. Their route had begun in New Hampshire and had included Anchorage, where they took jobs to collect enough money to venture into the bush. Like many other young couples who wished to get past the turnstiles of urban Alaska, they studied the map and guessed at the merits of this or that possible destination. Many people they enountered seemed to be headed for McGrath and Bethel and points between on the Kuskokwim River. Allen and Snow therefore looked the other way. "None of those people even knew where Eagle *was*. We figured it was the place to go."

They arrived in a pickup—with their axes and hammers, drill bits and drawknife, whipsaw; their new, lovely, seventeen-foot Chestnut Prospector canoe. They were exploring in more ways than the geographical. They were looking for a milieu—and a manner of developing their lives. For necessary money, they could work from time to time in Fairbanks—and, possibly, in Eagle. But they hoped to live much of the year apart from any community. "I reject suburbia," Snow was not shy to explain. "I reject crowds. I do not want a new car, a fancy house. They are not worth working for. In the Lower Forty-eight, economic pressure made it impossible for me to have the land and space I would like to have without spending twenty years to get it and then being surrounded by box houses. In order to get anything like what I wanted, in New Hampshire, I would have had to deal in large figures. I was unwilling to complicate my life to get those figures."

What he and Lilly sought was terrain where the individual spirit might be confined only by the metes and bounds and rules of nature. They meant to go down the Yukon, whose banks were just the beginnings of millions of acres of wilderness. They asked around—of others, like Dick Cook, who had pursued the same idea—and they discovered the country's code of seniority right. Tributary rivers were prime locations. There was

someone already living on each incoming stream for a considerable distance below Eagle. The first vacancy was the Nation River, forty-six miles away—a little far, but it would do. Snow had brought with him a sense of impending catastrophe, in large part because he had staked his plans on the character of the Yukon without even knowing if it was safely navigable or a boiling fume of rapids. When he had become assured that for all its great power the big river ran smooth, his confidence improved. He felt expansive as he loaded the canoe with seven hundred pounds of grain.

He was an electrician by trade—a fact of no value on the Nation. He was good at carpentry, though, and he was a sharpshooter—skills enough for a beginning. Seven miles up the Nation, he and Lilly built a ten-by-fourteen-foot cabin of unpeeled, saddle-notched logs. It had two windows, paned with soft clear plastic. It was chinked with moss. Its roof consisted of layers of sod, moss, and plastic. It was a tight, well-made, neatly made cabin. Its door, for some months, was nothing more than a hanging blanket, but even on nights at thirty-five below zero the cabin was so warm that the blanket was kept to one side. They had an airtight heat stove ("a poor man's Ashley"), and their cookstove was a sheepherder's unit, its firebox scarcely a cubic foot. With the whipsaw, Snow made boards for a bench and a table. From dry spruce he made dowels, which he tapped into holes drilled in the wall logs, and on these he set shelves for their pinto beans and bulgur, their whole-wheat-soy ribbon noodles, their cherry butter and corn-germ oil, rolled oats, popcorn, brown rice, and wheat berries. He killed a moose, and they hung strips of the meat from the ridgepole to dry. They preserved blueberries, cranberries, rose hips. In the clear Nation, they fished for grayling and northern pike.

They had only two dogs with them, and one night Miki, a Siberian husky, was off scenting the neighborhood when Snow and Allen heard the nearby howl of a wolf. Snow took a shotgun and

A log cabin surrounded by the brief summer glow of blossoming fireweed.

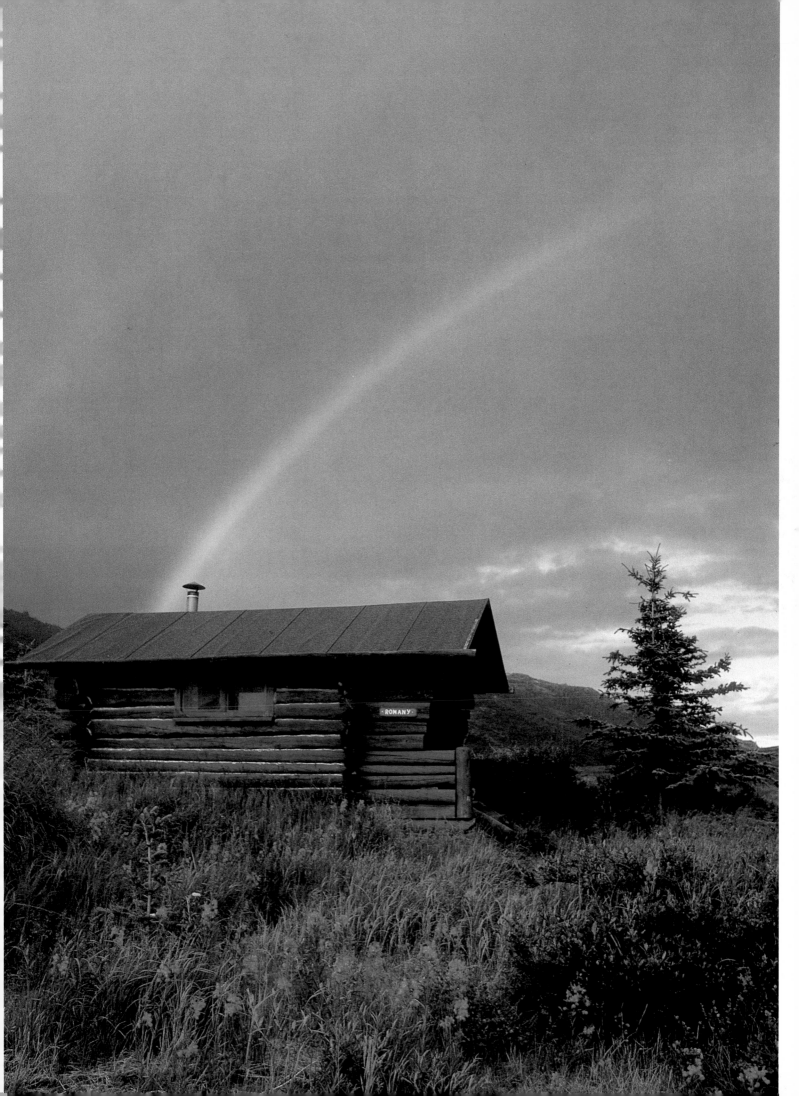

walked in the direction of the sound. He came back with Miki on a stick. The wolf had ripped the dog's throat. The winter was otherwise safely uneventful, with the exception that Snow one day decided he had appendicitis and took off for Fairbanks, leaving Lilly Allen behind. For five weeks, she was there alone, more than fifty miles from Eagle, with no idea if he was dead or alive. In the end, it was Snow's woman, and not his appendix, that was inflamed.

Not many months before, they had made a trip to Basking Ridge, New Jersey, to be married. The bride's father wore lilies of the valley. He is an Exxon executive. Lilly went to Ridge High School and for one semester to the University of Arizona. She was working as a waitress on Route 16 outside Conway, New Hampshire, when Snow came into her life. She wanted someday to own fields of sheep, she told him, because she was "into spinning and weaving." He wanted to go where even fleece would freeze. He was from Reading, Massachusetts, had studied some at the Universities of Massachusetts and Hawaii, and had been to trade school, but he had found a deeper interest working in New Hampshire forests for the Appalachian Mountain Club. A lithe man of middle height, he has a big brown beard, a tumble of shining brown hair, a serious turn of mind. Lilly Allen—handsome, unadornedly feminine—is facially Puritan, sober, with a touch of anachronism about her, as if on Sundays somehow she occupies a front pew, listening to Cotton Mather.

"We came here to get away from lots of people, lots of machines, and into a simpler way of life," she will say. "Everybody in Eagle says they came here 'to get away from it all.' We found 'it all' in Eagle. We came here to do without unnecessary things, to live out, to deal with the land in a more natural way."

In the vernacular of the river people, hunting moose, caribou, porcupine, duck, bear, rabbit is known as "getting your meat," and for Snow the task was complicated from the beginning by more than the problems of stalking and marksmanship.

He had trouble, sometimes, pulling the trigger on a wild creature. "I hunt for meat, but I don't really enjoy hunting," he confesses. "It comes down to having or not having a spirit of predatorship. If Dick Cook or Charlie Edwards sees a goose, he doesn't hesitate. Bang. But I stop and admire the goose, and then I think of the gun. When I shoot a moose, I walk up to it with profound reverence—this beautiful beast that I, a scrawny little thing, am destroying. The last time I shot my moose, I cried. I really sympathized with him. I don't know how to put it. Having shot the animal—and seeing it lying there, dying—shakes me up."

In their search for ways to make a living in the country, Snow and Allen avoided trapping altogether. "I would do that if I had no other way to get money," he explains. "But I don't want to kill animals up here to clothe fat whores in New York. I don't mind wearing furs, but I prefer not to sell them." Meanwhile, there was money to be made fighting fires—in a smoking forest with a water bag on his back—and from two such experiences he earned a thousand dollars, or more than half of what they needed for a year.

They were still tasting their new and more natural life when Lilly's parents arrived for a visit in Eagle. In two canoes, the four went down the Yukon for a few days, just to have a look at the cabin on the Nation. The journey was more than Lilly's mother could complete, but Snow and his father-in-law left the women camped behind and tracked the Chestnut up the stream. It was a laborious effort, and they had been at it several hours when a helicopter suddenly came over the trees and passed them. Just the sight of it angered Snow, because—fifty miles from civilization—it ruined the wild scene. The two men tracked on, forgot the chopper, and finally arrived at the cabin. It had a door now, and an ingenious Oriental-puzzle sort of lock, which Snow had devised. Scarcely had he brought out some gear to air when the helicopter returned. It circled, landed on a gravel bar. "Let me do the talking," said Snow.

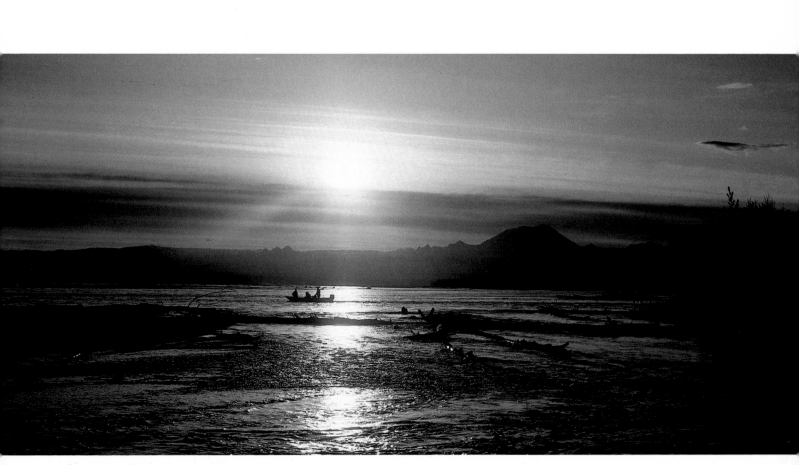

Boat on the Susitna River.

The pilot got out, and so did a man with a federal patch on his shirt. He was a short, slight briefcase of a man. "Hello," he said. "I'm Dave Williams, of the Bureau of Land Management. You're on a canoe trip. I'm very sorry to disturb your wilderness experience. We're just checking here. Do you mind if we look around? This isn't your place, is it?"

Snow was noncommittal, but he became increasingly irritated as Williams went into the cabin and rummaged among its goods. The pilot said, "Really nice place here—nice, well-built cabin. This your place?"

Brad and Lilly own a framed copy of a celebrated photograph made by Dorothea Lange in Kern County, California, in the nineteen-thirties, which shows a compressed-air pump at a rundown rural filling station and two prominent signs—one saying "AIR," the other saying "This is your country. Don't let the big men take it away from you."

"Yes, it's *my* place," Snow blurted.

Williams reappeared like a genie. "Did you say *your* place?" he asked.

"Those are my things in the cabin," Snow said. "I'd rather you didn't go through my things."

"I said, 'Is this your place?'"

"You seem to think it's yours."

As he left, Williams said, "The cabin is in trespass. Very likely you'll be hearing from me in a short while. This is now the twentieth century. You can't just do what you want to do. You cannot play with the wilderness."

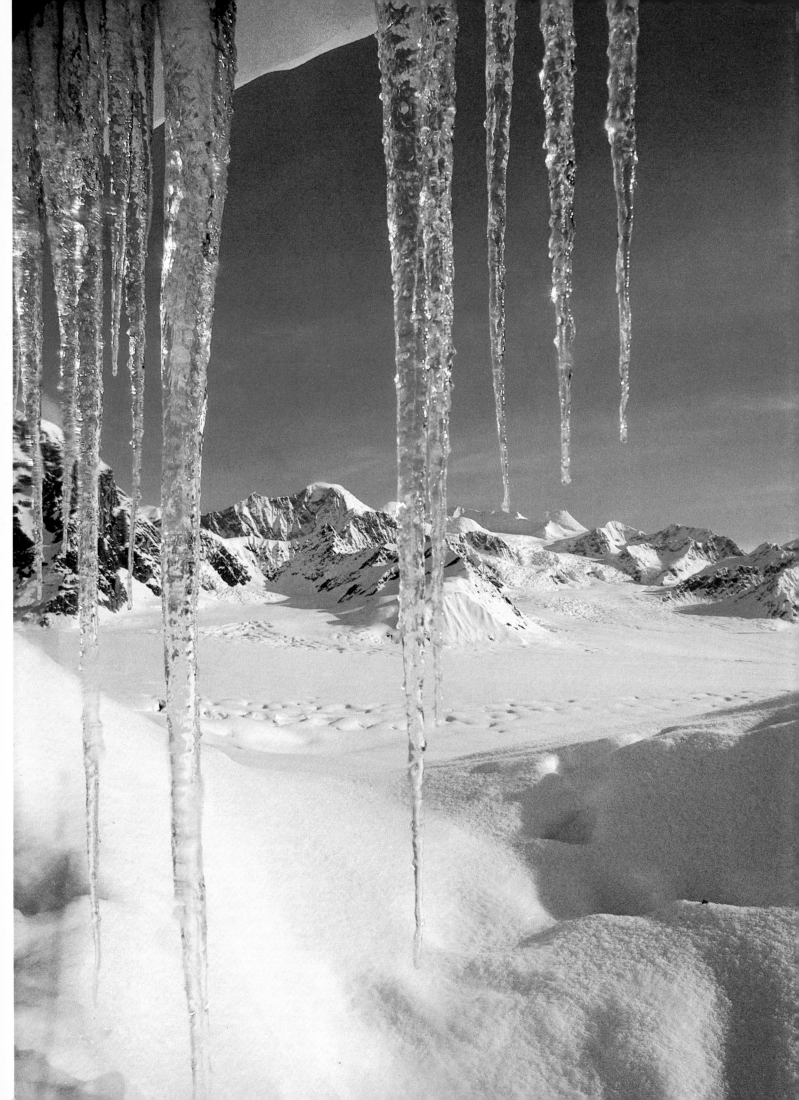

THE COUNTRY is full of stories of unusual deaths—old Nimrod Robertson lying down on a creek in overflow and letting it build around him a sarcophagus of ice; the trapper on the Kandik who apparently knocked himself out when he tripped and fell on his own firewood and froze to death before he came to—and of stories also of deaths postponed. There are fewer of the second. I would like to add one back—an account that in essence remains in the country but in detail has largely disappeared.

On a high promontory in the montane ruggedness around the upper Charley River lies the wreckage of an aircraft that is readily identifiable as a B-24. This was the so-called Liberator, a medium-range bomber built for the Second World War. The wreckage is in the dead center of the country, and I happened over it in a Cessna early in the fall of 1975, during a long and extremely digressive flight that began in Eagle and ended many hours later in Circle. The pilot of the Cessna said he understood that the crew of the Liberator had bailed out, in winter, and that only one man had survived. I asked around to learn who might know more than that—querying, among others, the Air Force in Fairbanks, various old-timers in Circle and Central, some of the river people, and Margaret Nelson, in Eagle, who had packed parachutes at Ladd Field, in Fairbanks, during the war. There had been one survivor—everyone agreed. No one knew his name. He had become a symbol in the country, though, and was not about to be forgotten. It was said that he alone had come out—long after all had been assumed dead—because he alone, of the widely scattered crew, was experienced in wilderness, knew how to live off the land, and was prepared to deal with the hostile cold. Above all, he had found a cabin, during his exodus, without which he would have died for sure.

If the survivor had gone on surviving for what was now approaching thirty-five years, he would in all likelihood be somewhere in the Lower Forty-eight. When I was home, I made a try to find him. Phone calls ricocheted around Washington for some days, yielding only additional phone numbers. The story was just too sketchy. Did I know how many bombers had been lost in that war? At length, I was given the name of Gerard Hasselwander, a historian at the Albert F. Simpson Historical Research Center, Maxwell Air Force Base, Alabama. I called him, and he said that if I did not even know the year of the crash he doubted he could help me. Scarcely two hours later, though, he called back to say that he had had a free moment or two at the end of his lunch hour and had browsed through some microfilm. To his own coniderable surprise, he had found the survivor's name, which was Leon Crane. Crane's home when he entered the Army Air Forces had been in Philadelphia, but Hasselwander had looked in a Philadelphia directory and there was no Leon Crane in it now. However, he said, Leon Crane had had two brothers who were also in service—in the Army Medical Corps—during the Second World War. One of them was named Morris. In the Philadelphia directory, there was a Dr. Morris Crane.

When I called the number, someone answered and said Dr. Crane was not there.

I asked when he would return.

"I don't know," was the reply. "He went to Leon's."

The Liberator, making cold-weather propeller tests above twenty thousand feet, went into a spin, dived toward the earth, and, pulling out, snapped its elevator controls. It then went into another spin, and the pilot gave the order to abandon ship. There were five aboard. Leon Crane was the co-pilot. He was twenty-four and he had been in Alaska less than two months. Since the plane was falling like a swirling leaf, he had to drag himself against heavy centrifugal force toward the open bomb bay. He had never used a parachute. The outside air temperature was at least thirty degrees below zero. When he jumped, he forgot his mittens. The day was December 21st.

87

View from a cabin window on an April morning in the Alaska Range.

Frost coats a spruce forest on a ridge above Eagle just before winter's first storm.

After a couple of weeks on the river, he found another cabin, with a modest but welcome food cache—cornmeal, canned vegetables, Vienna sausage. He sewed himself a backpack and abandoned his cumbersome sled. Some seven or eight days on down the river, he came around a bend at dusk and found cut spruce tops in parallel rows stuck in the river snow. His aloneness, he sensed, was all but over. It was the second week of March, and he was eighty days out of the sky. The arrangement of treetops, obviously, marked a place where a plane on skis might land supplies. He looked around in near darkness and found a toboggan trail. He camped, and next day followed the trail to a cabin—under smoke. He shouted toward it. Al Ames, a trapper, and his wife, Neena, and their children appeared in the doorway. "I am Lieutenant Leon Crane, of the United States Army Air Forces," he called out. "I've been in a little trouble." Ames took a picture, which hangs on a wall in Philadelphia.

Crane remembers thinking, Somebody must be saving me for something, but I don't know what it is. His six children, who owe themselves to that trip and to Phil Berail's fully stocked Charley River cabin, are—in addition to his three sons in the construction business—Mimi, who is studying engineering at Barnard; Rebecca, who is in the master's program in architecture at Columbia; and Ruth, a recent graduate of the Harvard Medical School. Crane himself went on to earn an advanced degree in aeronautical engineering at the Massachusetts Institute of Technology, and spent his career developing helicopters for Boeing Vertol.

"It's a little surprising to me that people exist who are interested in living on that ground up there," he told me. "Why would anyone want to take someone who wanted to *be* there and throw them out? Who the hell could *care?*"

Al Ames, who had built his cabin only two years before, harnessed his dogs and mushed Crane down the Yukon to Woodchopper, where a plane soon came along and flew him out.

Crane met Phil Berail at Woodchopper, and struggled shyly to express to him his inexpressible gratitude. Berail, sixty-five, was a temporary postmaster and worked for the gold miners there. He had trapped from his Charley River cabin. He was pleased that it had been useful, he said. For his part, he had no intention of ever going there again. He had abandoned the cabin four years before.

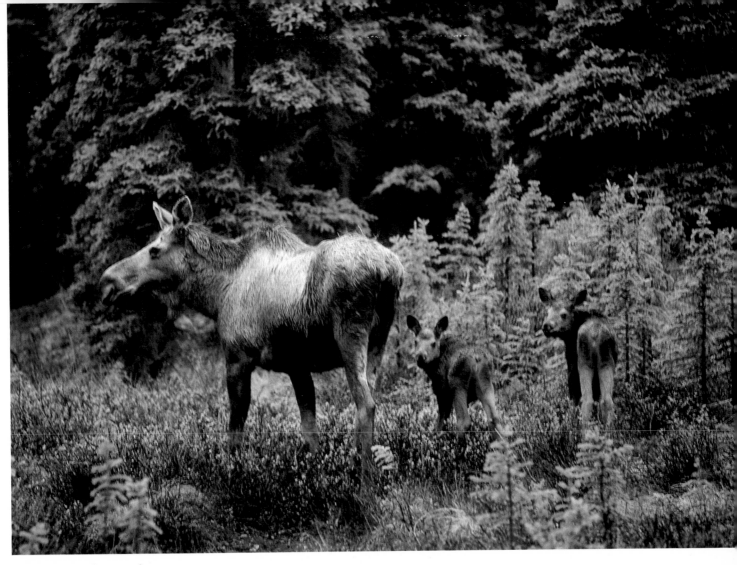

Cow moose and twin calves.

STANLEY GELVIN grew up in the country, and therefore has no capacity to see it as exotic. He has sampled other worlds, which have failed to attract him—Fairbanks, mainly, and a visit or two outside. He has spent most of the nights of his life in sleeping bags. When he sleeps in a bed with sheets and blankets, he turns, tosses, and flips until the bedding is out of tuck and is composed in mummy shape around him. While Stanley was growing up, Central, Alaska, with its population under twenty, did not offer him a large reserve of playmates. Instead, he had engines. Getting to know them, he acquired a primary skill of the country, and now has almost a maker's sense of their design and function. In mining, hunting, trapping, ice fishing, he and his family used everything from rasping little two-cycle chain-saw engines to the turbocharged diesel of the D9 Cat. They have pumps, generators, airplanes, snow machines, washing machines, automobiles, pickups—and when you are well over a hundred miles from the corner garage you do not go there to have someone listen to what seems to be wrong. Stanley, in his middle twenties, has never known that sort of dependence. Like his father, Ed Gelvin, he routinely works on the pumps, the saws, the cars, the planes. "Living in the bush, you have to," he says. "I don't know anything different. You just have to be a good mechanic. You have to modify machinery until you get the imperfections out. I never found nothing I couldn't fix."

From early youth onward, Stanley's gold fever has been chronic, running along steadily a few

ten courses of logs. There are many dozens of books, a core sample of which would be "Scotty Allan, King of the Dog Team Drivers," "Mining Engineers' Handbook," "Developing Gold Properties with Airplane Placer Drills," "The Home Physician and Guide to Health," "Yukon Women," "Fifty Years Below Zero," "Ancient Men of the Arctic," "The Call of the Wild," "The Wilderness Trapper," "The Trail Eater," "Grizzly Country," "Notorious Grizzly Bears," and "Return of the Alaskan." A waist-high bookshelf separates the kitchen area from the living room, where a couch and a couple of chairs – the walls, too – are draped and decorated with the long soft pelts of timber wolves. A full basement is below. There are five rooms in all. The wolf bitch Tara was not named for this house, but there is more analogy than meets the eye, for it is as handsome a cabin as there is in the country, and could be a setting to remember if the life here were to vanish with the wind.

WHEN I HAVE STAYED with the Gelvins, I have for the most part occupied a cabin toward the far end of the airstrip – a place they acquired not long ago from an old-timer named Curly Allain, who was in his seventies and went south. He had no intention of returning, but he left his cabin well stocked with utensils, food, and linen – a tin of coffee close to the pot, fifty pounds of flour, five pounds of Danish bacon, firewood in three sizes stacked beside the door. Outside, some paces away, I have stood at a form of parade rest and in the broad light of a June midnight been penetrated in the most inconvenient place by a swarm of indecent mosquitoes, and on the same spot in winter, in a similar posture at the same hour, have stared up in darkness from squeaky snow at a green arch of the aurora, green streamers streaming from it all across the sky. At home, when I look up at the North Star I lift my eyes but don't really have to move my head. Here, I crane back, lift my chin almost as far as it will go, and look up at the polestar flirting with the zenith. The cabin is long

and low, and its roof is loaded white – mantled eighteen inches deep. Its windows are brown-gold from the light of burning lamps. The air is so still I can hear the rising smoke. Twenty-two degrees below zero. Balls of ice are forming in the beard. I go back inside and comb it off, and jump into a bag of down.

The spruce in their millions are thick with snow, but not heavy snow – a light dry loaf on every bough, with frost as well, in chain crystals. Just touch one of these trees and all of its burden falls, makes craters in the snow of the ground. The load is so delicately poised a breath can break it, a mild breeze denude the forest. Day after day, the great northern stillness will preserve this Damoclean scene, while the first appearance of each February dawn shoots pink light into the trees, and colors all the blanketed roofs, the mushroom caps on barrels and posts. Overhead, sometimes, a few hundred feet above the ground stillness, the wind is audibly blowing. . . .

A number of times a day, as I walk back and forth between Curly's cabin and the main one, I pass Tara, in her pen. Not only is she fenced in, she is also chained to a stake – a double precaution. I have spoken in a soft soothing voice in her direction for weeks on end, but I remain a stranger, and whenever I come near her she races around her stake in the tight circles it prescribes, while from her throat comes a threat so guttural and wild that it calls into question the strength of the chain and the fence. Her mother was pure wolf, from Anaktuvuk Pass, dug out of a den by Eskimos. Tara – pale, silken, a flowing runner when she pulls a sled – has the long legs of the timber wolf, and they fairly whirl her around the stake, a flying blur, but, as fast as they move her, her eyes are always on mine. Her eyes are ochre. She once got out, and slit the throat of Andrea's pet dog, Lazarus. Lazarus survived. But I have no doubt that if Tara were to come off that chain and out of that pen as I am passing by, there would be nothing much left of me but a rubber hoof and a little hair on the unencircled ground.

100

One summer day, Ed and I made a two-hundred-and-fifty mile run in the pickup to collect a shipment of dog food in Fairbanks. Not far from town, we came to the Trans-Alaska Pipeline, which descended a long incline like a pneumatic message system in an as yet incomplete department store. We pulled off the road to contemplate this wonder; and as we sat there Ed mentioned an oil-drilling rig he had helped assemble in the far north, years ago. It had a jackknife mast. "You do the work on the ground, and then the thing stands up–a hundred and fifty-seven feet high." He had done all of the welding, in winter, with temperatures at forty and fifty below.

"How was that?"

"Pretty cold, most of the time."

The rig drilled a dry hole, and then was moved sixty miles to try again. The second drilling found oil. It was the discovery well of the 1968 oil strike in Arctic Alaska, and was called Prudhoe Bay State No. 1.

Across a sea of fresh dirt, a D9 Cat with a side boom was holding a section of pipe in a sling. Welders, with their pinpoint fires, were beading away, making a butt-weld joint. We walked over for a closer look. With their face masks, their heavy suiting (against cold that did not happen to be there), they looked like astronauts. Ed said they had six passes to make, six revolutions of the pipe–the first bead, the hot pass, the filler (three times), and the cap. The pipe was no wider than the spread of a child's arms, but nonetheless the work seemed to me long and tedious. "To me it's not," Ed said. "You have to pay attention to see that the metal's going in there right." He spoke with the welders. He said he was surprised they weren't using low-hydrogen rods. The welders looked up with interest, and talked tensile strengths in Oklatexan accents. Unused rods were lying around in profusion on the ground. As we left, Ed picked up some, like a figure gathering flowers. One of the pipe welders–a big man in cowboy boots–called out, "Hey there, y'all don't need to do that. Y'all just back your truck up here

Pipeline worker.

and we'll give you some." Ed responded to the suggestion. Into the back of the pickup the welders set several cylindrical cans full of high-tensile rods. Driving away, Ed said the hourly wage those men got was no more than it would be in a place like New York. What attracted them was the overtime–ten- to fourteen-hour days, time and a half Saturdays and Sundays. Some miles up the road, we stopped and looked at another pipeline, of larger diameter, built many years ago on an eighty-three-mile route to carry water to float gold dredges. Ed said he resented the long struggle

101

carried on by environmentalists telling Alaskans they should not build their oil pipeline. The delays caused by the great battle had injured the state. "The pipeline is using resources," he said. "It's a way the state can pay their bills. It doesn't spoil the appearance of Alaska."

An hour later, we were looking from a summit pass long distances across the peaks of the country. We paused, taking it in, and he told me another story remembered from the North Slope. He and the others would now and again see a lone raven, flying over the flat tundra. It would fly on and on, close to the ground. Below the raven, almost always, was a running fox. Mile upon mile, the fox stayed under the raven. If the raven sped up a bit and settled to the ground, the fox then stalked the raven. When the fox sprang for the capture, the raven—at the last moment—would jump into the air, and fly on across the tundra, with the fox running below. The relationship was apparently static, a ritual equilibrium, a possible pantomime. One day, such a pair came flying and running almost into camp. The raven set down. The fox went into its assassin creep—one crafted step after another—and then made a sudden dash. The raven jumped into the air. After a short flight, it came down, and was again stalked and rushed by the fox. Again it made a short flight, and settled down, even closer to the crew. The fox renewed its subtle glide, this historically futile contest with the raven's eye. Once more came the move, the rush, the leap. The fox caught the raven, ate it on the spot, and left a pile of black feathers on the ground.

A raven's wings left these tracks in the snow after a difficult take-off in the thin, cold air of the Alaska Range.

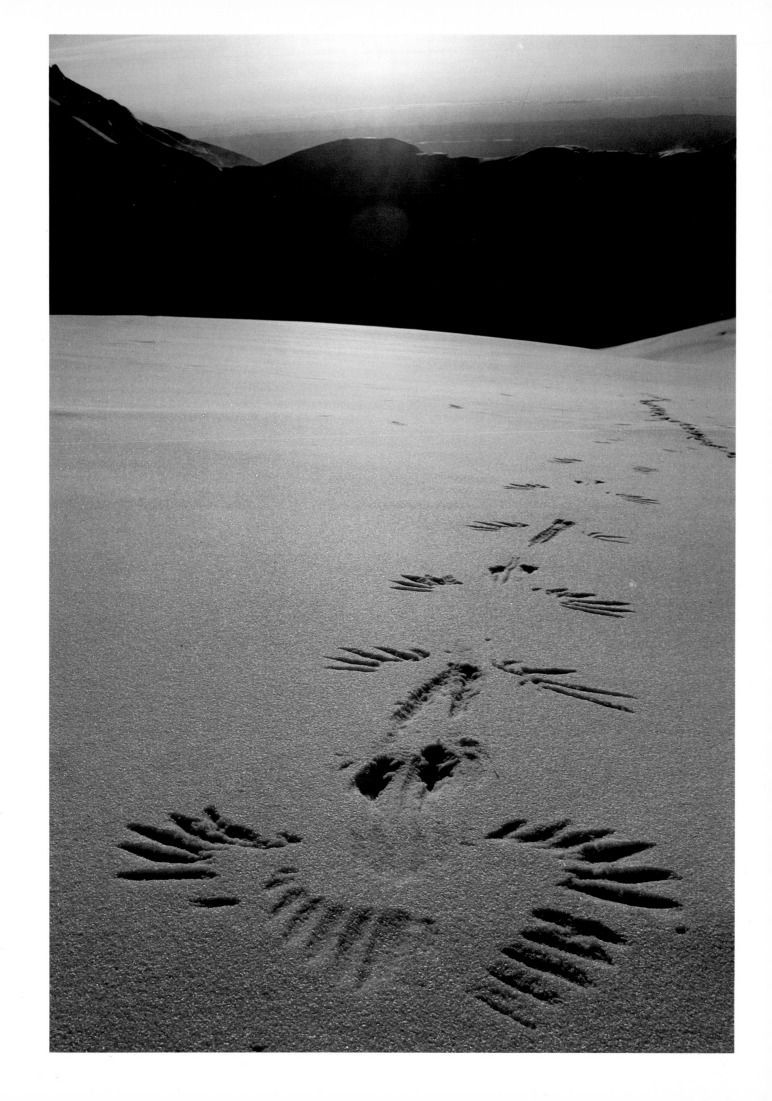

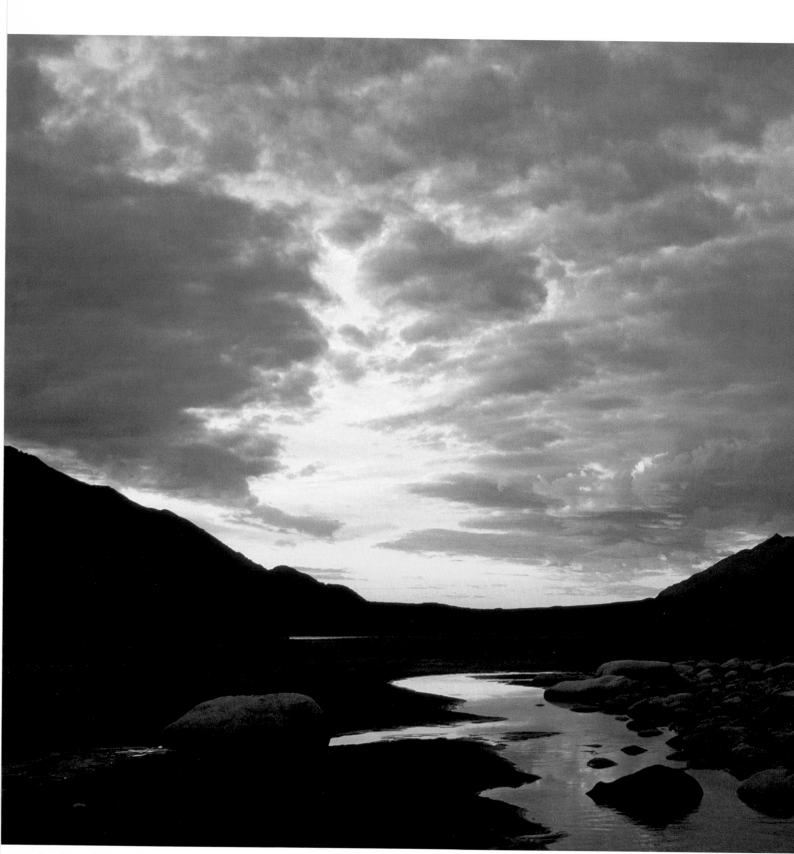

Midnight in the Brooks Range.

WE have moved completely out of the hills now, and beyond the riverine fringes of spruce and cottonwood are boggy flatlands and thaw lakes. We see spruce that have been chewed by porcupines and cottonwood chewed by beavers. Moose tend to congregate down here on the tundra plain. In late fall, some of the caribou that migrate through the Salmon valley will stop here and make this their winter range. We see a pair of loons, and lesser Canada geese, and chick mergansers with their mother. Mink, marten, muskrat, otter—creatures that live here inhabit the North Woods across the world to Maine. We pass a small waterfall under a patterned bluff—folded striations of schist. In bends of the river now we come upon banks of flood-eroded soil—of mud. They imply an earth mantle of some depth going back who knows how far from the river. Brown and glistening, they are virtually identical with rural stream banks in the eastern half of the country, with the difference that the water flowing past these is clear. In the sixteenth century, the streams of eastern America ran clear (except in flood), but after people began taking the vegetation off the soil mantle and then leaving their fields fallow when crops were not there, rain carried the soil into the streams. The process continues, and when one looks at such streams today, in their seasonal varieties of chocolate, their distant past is—even to the imagination—completely lost. For this Alaskan river, on the other hand, the sixteenth century has not yet ended, nor the fifteenth, nor the fifth. The river flows, as it has since immemorial time, in balance with itself. The river and every rill that feeds it are in an unmodified natural state—opaque in flood, ordinarily clear, with levels that change within a closed cycle of the year and of the years. The river cycle is only one of many hundreds of cycles—biological, meteorological—that coincide and blend here in the absence of intruding artifice. Past to present, present reflecting past, the cycles compose this segment of the earth. It is not static, so it cannot be styled "pristine," except in the special

sense that while human beings have hunted, fished, and gathered wild food in this valley in small groups for centuries, they have not yet begun to change it. Such a description will fit many rivers in Alaska. This one, though, with its considerable beauty and a geography that places it partly within and partly beyond the extreme reach of the boreal forest, has been thought of as sufficiently splendid to become a national wild river—to be set aside with its immediate environs as unalterable wild terrain. Kauffmann, Newman, Fedeler, and Pourchot are, in their various ways, studying that possibility. The wild-river proposal, which Congress is scheduled to act upon before the end of 1978, is something of a box within a box, for it is entirely incorporated within a proposed national monument that would include not only the entire Salmon River drainage but also a large segment of the valley of the Kobuk River, of which the Salmon is a tributary. (In the blue haze of Interior Department terminology, "national monument" often enough describes certain large bodies of preserved land that in all respects exept name are national parks.) The Kobuk Valley National Monument proposal, which includes nearly two million acres, is, in area, relatively modest among ten other pieces of Alaska that are similarly projected for confirmation by Congress as new parks and monuments. In all, these lands constitute over thirty-two million acres, which is more than all the Yosemites, all the Yellowstones, all the Grand Canyons and Sequoias put together—a total that would more than double the present size of the National Park System. For cartographic perspective, thirty-two million acres slightly exceeds the area of the state of New York.

Impressive as that may seem, it is less than a tenth of Alaska, which consists of three hundred and seventy-five million acres. From the Alaska Purchase, in 1867, to the Alaska Statehood Act, of 1958, Alaskan land was almost wholly federal. It was open to homesteading and other forms of private acquisition, but—all communities included—less than half of one per cent actually passed to private hands. In the Statehood Act, the national government promised to transfer to state ownership a hundred and three million acres, or a little more than a quarter of Alaska. Such an area, size of California, was deemed sufficient for the needs of the population as it was then and as it might be throughout the guessable future. The generosity of this apportionment can be measured beside the fact that the 1958 population of Alaska—all natives included—was virtually the same as the population of Sacramento. Even now, after the influx of new people that followed statehood and has attended the building of the Trans-Alaska Pipeline and the supposed oil-based bonanza, there are fewer people in all Alaska than there are in San Jose. The central paradox of Alaska is that it is as small as it is large—an immense landscape with so few people in it that language is stretched to call it a frontier, let alone a state. There are four hundred thousand people in Alaska, roughly half of whom live in or around Anchorage. To the point of picayunity, the state's road system is limited. A sense of the contemporary appearance of Alaska virtually requires inspection, because the civilized imagination cannot cover such quantities of wild land. Imagine, anyway, going from New York to Chicago—or, more accurately, from the one position to the other—in the year 1500. Such journeys, no less wild, are possible, and then some, over mountains, through forests, down the streams of Alaska. Alaska is a fifth as large as the contiguous forty-eight states. The question now is, what is to be the fate of all this land? It is anything but a "frozen waste." It is green nearly half the year. As never before, it has caught the attention of conflicting interests (developers, preservers, others), and events of the nineteen-seventies are accelerating the arrival of the answer to that question.

For a time, in the nineteen-sixties, the natives of Alaska succeeded in paralyzing the matter altogether. Eskimos, Indians, and Aleuts, in coordination, pressed a claim that had been largely

108

Fog rolling across the North Slope of the Brooks Range.

consist of extremely dense, compactly matted hair. The antler of the caribou is calcareous. It is hard bone, with the strength of wrought iron. Moving downhill and south across the tundra, we passed through groves of antlers. It was as if the long filing lines of the spring migration had for some reason paused here for shedding to occur. The antlers, like the bear, implied the country. Most were white, gaunt, chalky. I picked up a younger one, though, that was recently shed and was dark, like polished brown marble. It was about four feet along the beam and perfect in form. Hession found one like it. We set them on our shoulders and moved on down the hill, intent to take them home.

We headed for the next of the riverine mountains, where we planned to descend and – if our calculations were accurate – meet the river at the campsite. The river, far below us, now and again came into view as we walked abreast over open tundra. Fedeler, even more alert than usual, now stopped and, as before, touched my arm. He pointed toward the river. If a spruce needle had been floating on the water there, Fedeler would have seen it. We saw in an instant that we had miscalculated and were heading some miles beyond the campsite and would have come eventually to the river not knowing – upstream or downstream – which way to go. Fedeler was pointing toward a gravel bar, a thin column of smoke, minute human figures near the smoke, and the podlike whiteness of the metal canoe.

Another two miles, descending, and we were barefoot in the river, with pink hot feet turning anesthetically cold. We crossed slowly. The three others were by the campfire. On the grill were grayling and a filleted Arctic char. The air was cool now, nearing fifty, and we ate the fish, and beef stew, and strawberries, and drank hot chocolate.

After a time, Hession said, "That was a good walk. That was some of the easiest hiking you will ever find in Alaska."

We drew our route on the map and figured the distance at fourteen miles. John Kauffmann, tapping his pipe on a stone, said, "That's a lot for Alaska."

We sat around the campfire for at least another hour. We talked of rain and kestrels, oil and antlers, the height and the headwaters of the river. Neither Hession nor Fedeler once mentioned the bear.

When I got into my sleeping bag, and closed my eyes, there he was, in color, on the side of the hill. The vision was indelible, but fear was not what put it there. More, it was a sense of sheer luck at having chosen in the first place to follow Fedeler and Hession up the river and into the hills – a memento not so much of one moment as of the entire circuit of the long afternoon. It was a vision of a whole land, with an animal in it. This was his country, clearly enough. To be there was to be incorporated, in however small a measure, into its substance – his country, and if you wanted to visit it you had better knock.

His association with other animals is a mixture of enterprising action, almost magnanimous acceptance, and just plain willingness to ignore. There is great strength and pride combined with a strong mixture of inquisitive curiosity in the make-up of grizzly character. This curiosity is what makes trouble when men penetrate into country where they are not known to the bear. The grizzly can be brave and sometimes downright brash. He can be secretive and very retiring. He can be extremely cunning and also powerfully aggressive. Whatever he does, his actions match his surroundings and the circumstance of the moment. No wonder that meeting him on his mountain is a momentous event, imprinted on one's mind for life.

IN the morning there was wind. A front as dank as an oyster was moving in over the eastern mountains. Rain was coming—an uninviting day to frog kayaks in the river. We ate oatmeal, and then, after coffee, Jack Hession said he thought he'd be going. He had deadlines to meet and simply had to get back to the office. The office—in Anchorage—was six hundred miles away. If there was a wild place in the United States, we were in it, and Hession was about to take off on his own, pressed for time. Terribly sorry, he said. He would have enjoyed staying with us, but he had pressures from home. He had decided to make the trip with us more or less at the last moment, and now he was deciding to leave at the last moment plus one. He would take the mail plane from Kiana, which was something like ninety miles downstream. With a packet or two of freeze-dry and six pieces of pilot bread, he got into his single Klepper and bobbed down the river. The two blades of his paddle wagged like a semaphore, and he was gone. He had no tent. Rain fell through much of the day, and all through the night.

Hession told us, many days later, stories of his solo run. Not long after he left us, he became preoccupied with his thoughts and overshot a channel in a riffle. Near the far ends of pools, where loose-stone deposits had built up as dams, the river would characteristically become fast and shallow and would tumble to one side over a brink of gravel—racing white toward a lower pool. The knack of navigation was to read the riffle, sense the heaviest flow there, and get into it before the broad general current could take the boat a little farther and run it aground; for while much water went down the riffle even more simply disappeared into the earth, passing into the porous basements of high, dry bars of gravel. Often enough, there was just a narrow slot, angling left or right, through which the kayak could proceed, and now Hession had missed such a place, so he would have to backferry—moving, stern first, across the stream, to realign his course and shoot the rip. He was close to a bank. Realizing his mistake, he reached backward with his paddle. He happened to look up as well. On the bank above him were a sow grizzly and a huge two-year-old cub. Across a distance of no more than fifteen feet Hession and the mother grizzly looked each other in the eye. Staring steadily at her, he slowly moved the paddle, retreating at an angle to the current. He felt helpless, because he could think of nothing to do if the bear attacked. He thought of turning the boat over in order to disappear beneath it, but there was nowhere to hide in less than a foot of water. Therefore, all decisions belonged to the bear. Hession kept on gazing fixedly into her eyes, making no gesture of fear or flight. The bears themselves retreated. But after a few steps they turned, and both stood up on their hind legs, squinting. Hession thought they were going to come for him, after this second look. But they dropped down, turned, and went. He told this story without modulation, without a hint of narrative excitement; and in the same flat manner he went on to say that he had later seen a pair of sandhill cranes and, some time after that, a golden eagle. It was all wildlife to him. When you are the Sierra Club's man in Alaska, the least of your problems is bears.

That evening, when he decided it was time to sleep, the rain was steady and miserable, and he looked around for shelter. He looked for big driftwood. He finally came to an uprooted spruce, washed downriver probably in June. Resting on its root structure, it was partly off the ground. He tipped the kayak so that it leaned against the tree, and put his sleeping bag in the space formed between them. (As an alternative, he might have cut a number of young spruce and arranged them in a circle with their tips together at the top—a form of tepee that the forest Eskimos call "poor people's camp.") Hession slid himself into place. The rain fell on the boat and tree. "I passed out," he said, "and the next thing I knew it was morning." When he arrived at the confluence of the Salmon and the Kobuk, two Eskimos were fishing there. They shared their boiled salmon with him,

132

Rainbow and wild rose,
Mount McKinley National Park.

in a sauce of seal oil. Their Evinrude took him to Kiana.

John Kauffmann and I paddled Snake Eyes the day Hession left, and we spent a lot of time in the river beside it, making Klepper trails in the gravel. . . . The Nikok, a tributary, came into the Salmon from the west, and we stopped for lunch beside it, and cast lures from smooth ledges into deep holes that were clear and green.

After the Nikok, there was more river to float us. The rain turned to mist and put a soft gray light on the hills. No matter what the weather might

Tundra marsh.

be, Kauffmann said, the Brooks Range for him was the best of Alaska—in the quality of its light, in the clarity of its flowing water, in the configuration of its terrain. He did not much care for the glacier country—the south. "It's too raw," he went on. "Up here in the north, you have all the effects of the glacier land forms without the glaciers themselves. You have clear streams." Studying the Salmon as a national wild river had been Kauffmann's idea. If Kauffmann could have his way, at least a quarter of Alaska would be held as wilderness forever. After his five years of study and planning for Gates of the Arctic National Park—an area twice as large as the state of Hawaii, four times the size of Yellowstone—odds seemed favorable that it would be congressionally confirmed. Kauffmann's total plans for the park's development—his intended use of airstrips, roadways, lodges, lean-tos, refreshment stands, trash barrels, benches—added up to zero. The most inventive thing to do, as he saw it, was nothing. Let the land stand wild, without so much as a man-made trail.

Kauffmann, among Alaskans, represented only a small arc or two in a wheel of attitudes toward the land. For one thing, he was a "fed" and thus an "outsider," who—in the view of some—was trying to "grab" and "lock up" prime terrain. Yet he was also an Alaskan. In a state largely populated by aggressive transients, he was at least as Alaskan as most. He had built a home and had become an earnest Alaskan citizen. As such, and not merely as a fed, he did indeed favor locking up land, if that meant saving it for the future of the future.

In the time Kauffmann had lived in Alaska, the number of voters with views sympathetic to his own had risen from very low to modest. Yet the presence of this minority (backed by support from outside) had produced a tension that underlay much of what was happening in the state. It was tension over the way in which Alaska might proceed, tension somewhat reminiscent of the matters (water rights, grazing rights) that divided ear-

lier pioneers. In its modern form, it was the tension of preservation versus development, of stasis versus economic productivity, of wilderness versus the drill and the bulldozer, and in part it had caused the portentous reassignment of land that now, in the nineteen-seventies, was altering, or threatening to alter, the lives of everyone in the state.

The federal government, long ago, used to watch over Alaska with one eye, and with so little interest that the lid was generally closed. In all that territorial land, so wild and remote, emigrants from the United States easily established their frontier code: breathe free, do as you please, control your own destiny. If you had much more in mind than skinning hares, though, it was difficult to control much of a destiny—to plan, for example, any kind of development on a major scale—since the federal government owned more than ninety-nine per cent of the land. The push for statehood was seen as a way to gain more control; but, to their frustration and disappointment, Alaskans found that the big decisions continued to be made (or postponed, as the case might be) in Washington. After some years, and under pressure to find new energy resources, the federal government awakened to the potentialities of Alaska. With the development of the oil field at Prudhoe Bay, state and federal interests at last seemed to complement each other. The discovery of oil felt like the discovery of gold, and the future seemed lighted from behind. With the pipeline, however, Alaska suddenly had more development than it could absorb. It suddenly had manifold inflation and a glut of trailer parks. It had traffic jams. You could pick up a telephone and "dial a date." In the reasonably accessible bush, fishing and hunting—the sorts of things many people had long sought in Alaska—became crowded and poor. A boom was on, money was around, and buildings were going up; but a dream may have come too true. Most of the money was passing over the heads of Alaskans long established in the state. Confused and disillusioned, many were forced to ponder if big-scale development meant bonanza after all.

The people's new hesitation about the wisdom of development was expressed in 1974 in the election, by a narrow margin, of Jay Hammond as governor. Hammond had homesteaded land in Alaska. His wife was an Alaskan native. His approach to Alaska's future was to attempt to go slow, to build with caution, to try to find a middle course—not only *between* conservation and economic development but *within* them as well. He appointed Robert Weeden, a wildlife biologist

Lousewort and ice floes on the Arctic Ocean.

Bumper sticker and mud flaps make a joint statement of this Alaskan's views.

the nation relates to it. The state has gone from a development urge to development plus conservation, while the federal trajectory—in general—has been from neglect and preservation to exploitation of resources. We've almost changed roles. Meanwhile, federal agencies are scrapping among themselves. The National Park Service wants the land as it is, and the Forest Service and the Bureau of Land Management would like to see it exploited. The Fish and Wildlife Service is closer to the middle. Their lands are available for 'compatible uses.' For example, their Kenai National Moose Range has oil wells in it. The Moose Range was the first oil field in Alaska. The National Park Service and Fish and Wildlife are the conservationists' favorites. Developers favor the Bureau of Land Management. We need an additional approach. Suppose you have good parkland that also has minerals. You say a firm decision should not be made there—not right now. There are places where a reasonable man would not want to make decisions yet. Our position has been described by some as a middle-of-the-road stance. Perhaps so, but in this road all the traffic seems to be hugging the two ditches. These days, man should be somewhat humble about his *capacity* to make permanent decisions." On a wall in Weeden's offices, a sign said, "Earth, this is God. I want all you people to clear out before the end of the month. I have a client who is interested in the property."

I had lunch one day in Anchorage with an entrenched Alaskan boomer—Robert Atwood, editor and publisher of the Anchorage *Times.* If the state government and its Robert Weedens were about ninety degrees around from the attitude represented by John Kauffmann, Atwood was a hundred and eighty. "We should preserve wilderness only in areas that are without other resources," he said. "The U.S. needs our oil. We're not going to prevent it going. God damn it, they should take it. They need it. The ultimate destiny of Alaska is to help the nation be self-sufficient. We should bend and help, not tie the

from the University of Alaska, as State Policy Development and Planning Director, and set him the task of drawing together a state proposal for the future of the designated national-interest lands. Unsurprisingly, the state soon informed Congress that it would like to participate in the management of these lands, and hence was willing to put some of its own land into the total. The state would like various options to be left open for the future and not to be written away in legislation. "We're interested in sharing in the decisions on federal lands forever," Weeden told me one day in the capitol, in Juneau. "The federal proposals reflect the territorial imperative of agencies rather than the long-term interests of the state as

land up in a knot to save a tree or a bear or a fond dream. A state develops by developing its resources. Prudhoe Bay was a big start for this little state. Then what happened? The pipeline was stopped for years by conservationists. It was the first time in history that a state was told it could not take its resources to market. Some people think anybody who wants to do anything with a shovel is bad. They should see Prudhoe Bay. It's so damned clean and neat and sterile–with refrigerated pilings, so the tundra won't melt. The pipeline will be the biggest tourist attraction in Alaska. Caribou will move close to it for heat. Meanwhile, these wilderness buffs, like your friend Kauffmann, have an insatiable appetite for wilderness. They have drawn lines on the map according to what is best and beautiful from their point of view. What they are trying for is a land grab, but they see it as the last chance to preserve something. From their point of view, it *is* the last chance. But locking the land up is unfair to future generations. Nobody knows wholly what is under it, in coal or oil or minerals."

Alaskan natives, for their part, were somewhere on the way back to Kauffmann. They saw the federal park and refuge proposals as possibly–but not necessarily–the least disturbing of the changes that could come to, for example, the Salmon River and the Kobuk valley. Willie Hensley, an Eskimo leader, once described it this way for me: "If we can hunt, fish, trap, we're not concerned. We don't have that assurance yet. If we can't drive our boats up the river, we're going to have problems. If we can't take our dog teams or snow machines after caribou, we're going to have problems. Now is a time of transition for the native people. We have long used the land as if we owned it. We thought we *did* own it. We had lived here ten thousand years and assumed it was ours. But in the past we never had the political or economic clout to make a single bit of difference in Alaska. The Native Claims Settlement Act has given us a voice that we did not have before. It has also given us the problem of the national-interest

lands. If these lands can be used for subsistence hunting, fishing, trapping, we don't have many qualms." No less wary of the coming of the parkland were any number of whites living in the bush, who had also been trapping and hunting and fishing for (in many cases) generations, and who now found themselves confronted with much the same worries the natives had–but without the incidental benefits of a billion dollars and forty million acres of land.

Paddling on through the light rain, Kauffmann now began to fulminate. He said he had once drawn up an Alaskan coat of arms, its shield quarterly gules and gold with a motto written in each quarter, expressing what he took to be the core

Aleut Indian woman at seal harvest time on the Pribilof Islands in the Bering Sea.

Horned puffin, Pribilof Islands.

attitudes of the people of Alaska toward—as the Aleut word "Alaska" means—"the great land." The motto written on one quarter of the shield was "Dig It Up." On another, "Chop It Down." On another, "Fish It Out." On the fourth, "Shoot It." He said the forty million acres involved in the Native Claims Settlement Act amounted to something over six hundred acres for each native. He said the Statehood Act had provided what now amounted to two hundred and fifty acres for each Alaskan. And that left roughly one acre of Alaska for each citizen of the United States as a whole—an amount he considered minimal. "People who have come to Alaska, worked hard, and grubbed out a living feel resentment toward people whom they call 'Lower Forty-eight meddlers,'" he went on. "People here take a proprietary attitude. They say, 'Don't tie our hands.' They forget that we *all* own Alaska. They call it their land, but it's everybody's land. Alaska is the last great opportunity this nation has to set aside adequate chunks of natural landscape for a variety of conservation purposes. The land is still open. It is uncommitted. Think what the East would look like if Thoreau had been heeded. Think of the rivers and lakes of New Hampshire and Maine—Lake Winnipesaukee, Moosehead Lake. The opportunity exists in Alaska on a scale incomprehensible to anyone who hasn't seen it. Local interests should be satisfied, certainly, and state interests as well—but so should *national* interests. This river, this land around us, is of national interest, and it belongs to everybody in the United States."

In part to make him paddle harder, I said, "Yes, but why do all you sneakerfaces, you ecocentrics, think you need so much of it? Why do you need eighty million acres?"

"Everything in Alaska is on a bigger scale," he said. "There is a need for a place in which to lose yourself, for more space than you can encompass. It's not sufficient just to set aside sights to see. We need whole ecosystems, whole ranges, whole watersheds."

"Entire mountain ranges?"

"We're going to have to live in close harmony with the earth. There's a lot we don't know. We need places where we can learn how. The carrying capacity for plants and animals is limited here. They need plenty of space and time. Think of the years it takes a grayling to grow. If we do our thing, if we exploit shortsightedly, we impoverish even the biggest landscapes. There is no such thing as superabundance. I think many people have come to realize this. A sense of spaciousness has shaped the character of this country. We don't want to let that sense entirely pass. The frontier society feels it is here to exploit the land, though—to grow, to build, to tame, to extract, to realize the wealth that is here. They don't like regulation. They don't like to be told they can't do something. They want to do what they want to where and when they please. Between their interests and the interests of the nation as a whole the Native Claims Settlement Act tried to strike a balance."

"Some balance," I said. "The map is covered with proposed parks."

"The parks are ten per cent of the state, God damn it. Tithed to the future. The proposals are

138

not repetitious. They are different. They complement each other. This river and the Gates of the Arctic are at the wilderness end of the spectrum. This is the last big piece of magnificent mountain wilderness we have left. First it was the Appalachians, then the Rockies, then the Sierra Nevada, then Alaska, and this is the last part of Alaska. This is America's ultimate wilderness; it goes no farther. This is our last opportunity to provide, admittedly in a contrived way, the chance to go adventuring in a country so wild that valleys and mountains are without names."

"But why lock it up forever?"

"It will *not* be locked up. The resources aren't going to go anywhere. In some dire situation, they are there. People say, 'Study it first.' This is a delaying tactic by people who want to exploit it later. There's always someone who wants another look. Meanwhile, the time has historically come for preserving major pieces of land in Alaska, to have the freshness of Alaska—large landscapes, habitats—perpetuated, not tarnished and degraded as man grubs his way along with awesome power. The locations of oil reserves are largely determined. The national-interest lands include very little oil. What the contention comes down to is mining. Nineteenth-century laws let the miner onto most government land, but the miner is no longer the quaint old man with the burro and the pick."

Icebergs in a storm, Portage.

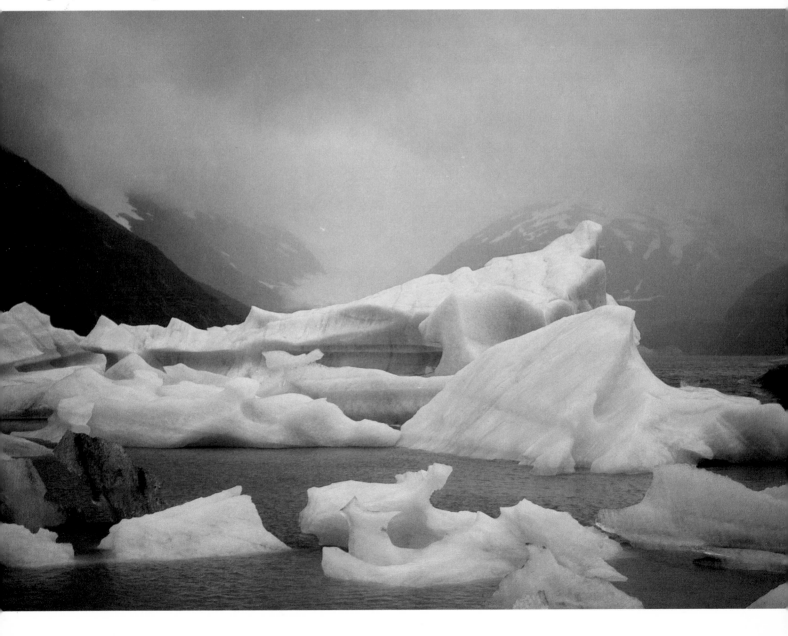

Having goaded him, I thought I should reward him. I said, "In Alaska, we appear to be recapitulating ourselves. This may be our last chance to suggest that we've learned anything at all." I felt the momentum of Snake Eyes perceptibly increase.

We came to the end of a pondlike pool, and Snake Eyes ran aground. Salmon were thrashing up the riffle there–backs exposed, sculling against water and stones. Toward the bottom of the rip, water collected, becoming heavy and white and two feet deep. The river then curved right–a bending chute with a cut bank on one side and an apron of gravel on the other. Over the cut bank a sweeper had recently fallen, a spruce whose trunk reached into the river. Its green boughs spread over the white water. The swiftest of the current went under the branches, so the problem presented to Kauffmann and me was to get into the kayak in fast water and then collect ourselves at once for a move around the tree. Sweepers tend to trap boats and hold them almost broadside to the current while the weight of the river rolls them over. Kauffmann and I attacked the situation with the same easy confidence we had displayed over the years on a number of analogous occasions, beginning with a near double drowning in 1955. Standing in the rain in the fast water, we settled into Snake Eyes and flew at the sweeper. In concept, we would skirt it to the right. In practice, we hit it dead center.

Kauffmann was still reminding me that this was our last opportunity to save the final American wilderness when Snake Eyes bought the river. The thought occurred to me as I pitched head first into the rushing water that I had not often involuntarily overturned on a river trip, and that on almost all the occasions when I had the last thing I had seen on my way to the bottom was Kauffmann. Tact restrained me from mentioning this to him until he had come up out of the river. Meanwhile, I jumped to my feet. The water was waist deep, cold as a wine bucket. I retrieved Kauffmann's hat. Under the gin-clear water, his head, with its radical economy of hair, looked like an onion. Snake Eyes was upside down. I wrenched it right side up, then took its painter and hurried out of the river. From the moment we spilled until I was standing on dry gravel, scarcely fifteen seconds went by. Kauffmann was soaked, but I was not. My rain gear had been drawn tight at the neck and had elastic cuffs. I was half wet–in harlequin patches, and not much on the chest or the back. A piece at a time, we floated our duffel out of Snake Eyes–sleeping bags, clothes bags. Then we dumped out the water, repacked the duffel, and got back onto the river.

We were chilled, and that was a long cold afternoon. Snake Eyes continued to move downstream like a sea anchor, and in the miserable rain we chose not to stop and build a fire. A few hours later, we embraced the fire that ended the day.

140

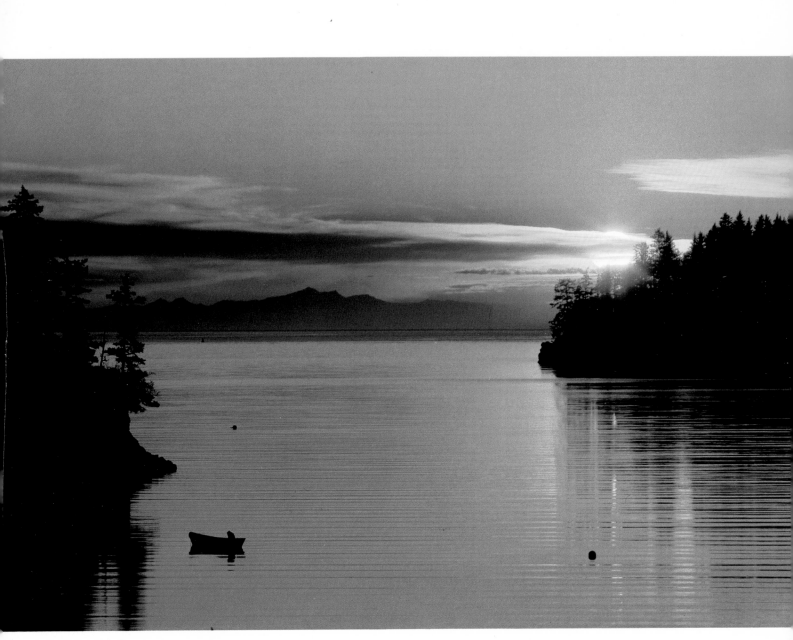

Sunset on Kachemak Bay, Kenai Peninsula.

A FIFTY-FIVE-GALLON steel drum is thirty-four and three-quarters inches high and twenty-three inches in diameter, and is sometimes called the Alaska State Flower. Hundreds of them lie around wherever people have settled. I once considered them ugly. They seemed disappointing, somehow, and I wished they would go away. There is a change that affects what one sees here. Just as on a wilderness trip a change occurs after a time and you cross a line into another world, a change occurs with these drums. Gradually, they become tolerable, and then more and more attractive. Eventually, they almost bloom. Fifty-five-gallon drums are used as rain barrels, roof jacks, bathtubs, fish smokers, dog pots, doghouses. They are testing basins for outboard motors. They are the honeypots of biffies, the

floats of rafts. A threat has been made to use one as a bomb. Dick Cook, who despises aircraft of all types, told a helicopter pilot he would shoot at him if he ever came near his home. The pilot has warned Cook that if he so much as points a rifle at the chopper the pilot will fill a fifty-five-gallon drum with water and drop it on the roof of Cook's cabin. Fifty-five-gallon drums make heat stoves, cookstoves, flower planters, bearproof caches, wood boxes, well casings, watering troughs, culverts, runway markers, water tanks, solar showers. They are used as rollers for moving cabins, rollers to smooth snow or dirt. Sliced on the diagonal, they are the bodies of wheelbarrows. Scavenged everywhere, they are looked upon as gold.

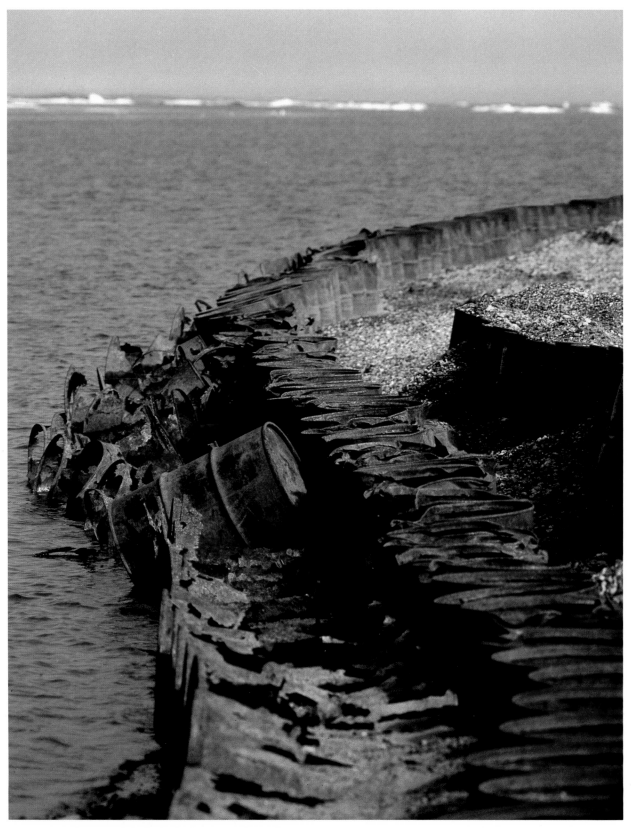

*Oil drums form a barrier against erosion where the
northern edge of the United States meets the Arctic Ocean.*

LIST OF PHOTOGRAPHS

144

53 Tundra frost in the hills above Eagle.
35 mm lens, Kodachrome 64; 1980.

55 First Avenue, Eagle.
15 mm lens, Kodachrome 64; 1980.

56 Seagull in the Alaskan Interior.
200 mm lens, Kodachrome 64; 1979.

57 A cabin on First Avenue, Eagle.
100 mm lens, Kodachrome 25; 1980.

59 Rainbow over the Yukon River, Eagle.
85 mm lens, Kodachrome 64; 1980.

60 Spring breakup on the Toklat River.
24 mm lens, Kodachrome II; 1973.

63 114-year-old Liza Malcolm.
85 mm lens, Kodachrome 64; 1980.

65 Eagle Indian Village on the banks of the Yukon.
55 mm lens, Kodachrome 25; 1980.

66 Alaskan brown bears.
400 mm lens, Kodachrome 64; 1979.

67 *top:* Lynx. 200 mm lens, Kodachrome 64; 1974.
bottom: Murres nesting above the Bering Sea.
400 mm lens, Kodachrome 64; 1979.

68 Abandoned gold dredge, the Jack Wade #1,
on a tributary of the Fortymile River.
24 mm lens, Kodachrome 25; 1980.

69 A miner from Eagle.
20 mm lens, Kodachrome 64; 1980.

71 Hotel at Circle Hot Springs.
15 mm lens, Kodachrome 64; 1980.

72 Recent placer activity in the Fortymile country.
35 mm lens, Kodachrome 25; 1980.

75 Frost softens the contours of a forest near Eagle.
85 mm lens, Kodachrome 25; 1980.

76 Old Episcopal church by the Yukon, Eagle.
24 mm lens, Kodachrome 64; 1980.

77 Soldier's quarters in the restored Fort Egbert,
Eagle. 15 mm lens, Kodachrome 64; 1980.

78 The Wickersham Courthouse in Eagle.
15 mm lens, Kodachrome 64; 1980.

79 Dog team on the Muldrow Glacier, Mount McKinley
National Park. 35 mm lens, Kodachrome 64; 1978.

81 Isolated, dwarfed spruce.
105 mm lens, Kodachrome II; 1972.

83 A log cabin surrounded by the brief summer
glow of blossoming fireweed.
100 mm lens, Kodachrome 25; 1979.

85 Boat on the Susitna River.
105 mm lens, Kodachrome 25; 1979.

86 View from a cabin window, Alaska Range.
24 mm lens, Kodachrome 25; 1978.

88 A beard becomes a tangle of ice.
105 mm lens, Kodachrome 64; 1978.

89 Arctic ground squirrels.
1200 mm lens, Kodachrome 64; 1979.

90 Frost coats a spruce forest on a ridge above Eagle.
85 mm lens, Kodachrome 25; 1980.

93 Band of Dall sheep.
200 mm lens, Kodachrome 64; 1980.

95 Cow moose and twin calves.
200 mm lens, Kodachrome 64; 1976.

101 Pipeline worker, near Delta.
600 mm lens, Kodachrome 64; 1980.

103 A raven's wings leave tracks in the snow.
24 mm lens, Kodachrome 25; 1979.

106 Midnight in the Brooks Range.
55 mm lens, Kodachrome 25; 1979.

109 Fog rolling across the North Slope of the
Brooks Range. 35 mm lens, Kodachrome 25; 1979.

110 Moss campion, North Slope.
20 mm lens, Kodachrome 64; 1979.

111 Midnight hike in the Brooks Range.
35 mm lens, Kodachrome 64; 1979.

112 Clearing storm over the Savage River.
24 mm lens, Kodachrome 25; 1980.

114 Caribou skull and rack near a wolf's den in the
Brooks Range. 24 mm lens, Kodachrome 64; 1979.

115 Barren ground caribou on the run.
400 mm lens, Kodachrome 64; 1979.

119 Fording a glacial river.
105 mm lens, Kodachrome 64; 1979.

120 *top:* Bull moose bedded down during rut.
400 mm lens, Kodachrome 64; 1980.
bottom: Gray wolf in a thicket of fireweed
and willow. 400 mm lens, Kodachrome 64; 1979.

121 *left:* Lupine leaves in the tundra.
55 mm lens, Kodachrome 64; 1979.
right: Phlox on a barren Brooks Range summit.
55 mm lens, Kodachrome 25; 1979.

122 Abandoned bulldozer, North Slope, Brooks Range.
55 mm lens, Kodachrome 25; 1980.

125 Brown bear sow nursing her twin cubs in an
open glade. 600 mm lens, Kodachrome 64; 1979.

126 Stand-off with an Alaskan brown bear.
55 mm lens, Kodachrome 64; 1979.

130 Brown bear fishing.
600 mm lens, Kodachrome 64; 1979.

133 Rainbow and wild rose, Camp Denali.
35 mm lens, Kodachrome 25; 1979.

134 Tundra marsh. 35 mm lens, Kodachrome 64; 1979.

135 Lousewort and ice floes on the Arctic Ocean.
55 mm lens, Kodachrome 25; 1979.

136 Trailer with bumper sticker and mud flaps.
105 mm lens, Kodachrome II; 1973.

137 Aleut Indian woman at seal harvest time on the
Pribilof Islands. 200 mm lens, Kodachrome 64; 1979.

138 Horned puffin, Pribilof Islands, Bering Sea.
400 mm lens, Kodachrome 64; 1979.

139 Icebergs in a storm, Portage.
55 mm lens, Kodachrome 64; 1980.

141 Sunset on Kachemak Bay, Kenai Peninsula.
200 mm lens, Kodachrome 25; 1976.

143 Oil drums, Arctic Ocean.
200 mm lens, Kodachrome 25; 1980.

146 Fireweed growing through spruce boughs,
McKinley Park. 105 mm lens, Kodachrome 25; 1979.